Robert McCloskey

A Private Life in Words and Pictures

Robert McCloskey

A Private Life in Words and Pictures

JANE McCLOSKEY

Jane McCloskey

SEAPOINT BOOKS

AN IMPRINT OF SMITH/KERR ASSOCIATES LLC

KITTERY POINT, MAINE

WWW.SMITHKERR.COM

Distributed to the trade by National Book Network

Generous quantity discounts are available through Smith/Kerr Associates LLC, 43 Seapoint Road, Kittery Point, ME 03905 (207) 439-2921 or www.SmithKerr.com

Cataloging-in-publication data is on file at the Library of Congress.

ISBN-13 978-0-9786899-6-4

ISBN-10 0-9786899-6-8

Cover and book design by Claire MacMaster, Barefoot Art Graphic Design, www.deepwater-creative.com

Printed in China through Printworks Int. Ltd.

dedication and thanks

For my parents.

Thanks to all the people who helped me with this book.

Tom Leigh who took the photographs of my father's paintings and sketches.

Nancy Schön for her photograph of the ducks in the Boston Public Garden.

The Butler County Historical Society for stories of my father's youth and the newspaper stories about his visit to Hamilton.

Edee Howland for her painting that my father did of Coveacres.

Morton Schindel and Weston Woods for the photographs of Bob's puppets.

Samantha Hawkins for the watercolor she did of Little Deer Isle.

Regina Hayes and Mary Sullivan of Viking Penguin for helping with permissions.

My editor and publisher Spencer Smith, and his partner Jean Kerr who had faith in my book and knew how to improve it.

Renee Nichols who, in addition to copy editing, further improved it.

Claire MacMaster, who made a handsome layout and cover design for the book.

Sal for being my sister.

My parents.

credits

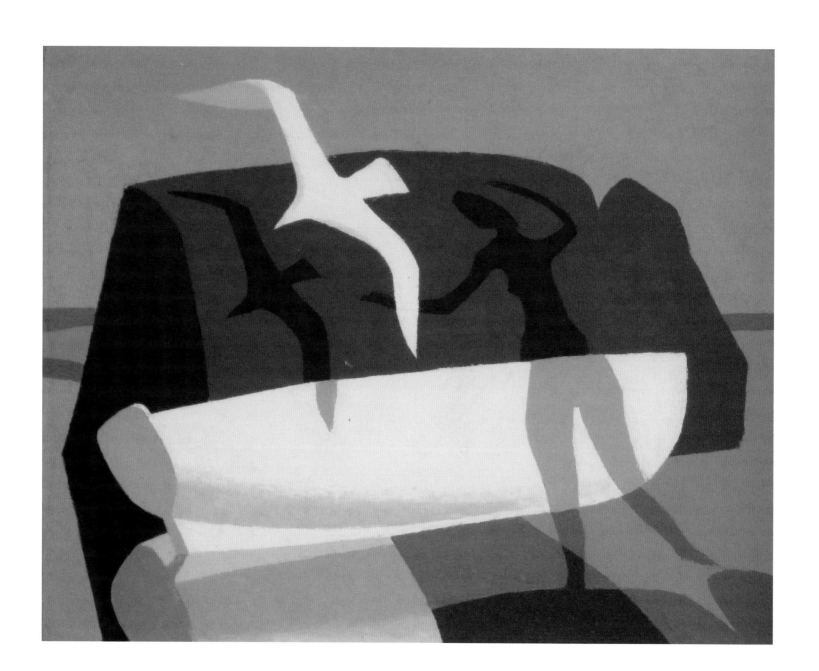

contents

Robert McCloskey 1914-2003

My father, Robert McCloskey, was one of the best known and loved children's authors and illustrators of the twentieth century.

His best-known book is probably *Make Way for Ducklings*, about a family of ducks who move to the Boston Public Garden. This book won the Caldecott Medal in 1941 for the best illustrated children's book of the year. In 1985, the sculptor Nancy Schön made bronze statues of the Ducks, which were placed in the Public Garden.

In 1991, the United States and Soviet Union made peace after the long Cold War. While Mrs. Gorbachev was visiting the United States, Mrs. Barbara Bush took Mrs. Gorbachev to see the Ducks in the Boston Public Garden. After talking it over with Mrs. Gorbachev, Mrs. Bush gave a set of replica Ducks from the children of the U.S. to the children of the U.S.S.R. My father and Nancy Schön went to Moscow with the Bushes for the signing of the START treaty and the installation of the new Ducks.

Another well-loved book is *Blueberries for Sal*, a make-believe story about my sister, Sal, and my mother, who go blueberry picking and get mixed up with a little bear and her mother.

Another favorite book in the state of Maine is *One Morning in Maine*. In this story, Sal loses her tooth when she goes clam digging with my father. Later, Sal, my father, and I make a trip to Buck's Harbor for groceries, and come home to Mom, who has made clam chowder for lunch!

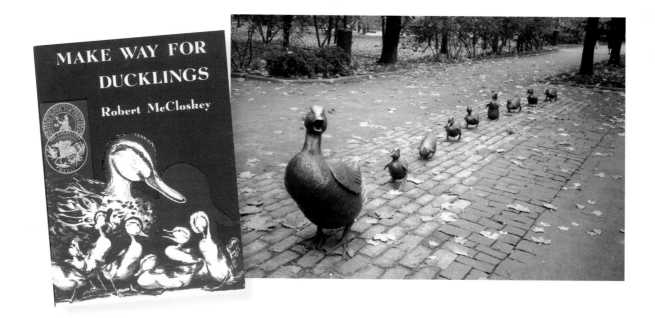

My favorite of my father's books is *Time of Wonder*. It is the story of a summer Sal and I spend on our family's island in Maine. I like to think that this book was written for me, since I am the dreamer and wonderer in our family. *Time of Wonder* won the Caldecott Medal in 1957. My father was the first person ever to win the Caldecott twice.

My father, whom we called Bob, also wrote from his own boyhood experiences. *Lentil* was Bob's first book, about a boy who cannot whistle or sing, so he learns to play the harmonica. What with one thing and another, Lentil's harmonica playing saves the day when the local town dignitary returns home.

Homer Price and *Centerburg Tales* are about a boy in a small town who has various adventures, including one with a run-amok doughnut machine.

Where I live in Maine, many local people say that *Burt Dow, Deep-Water Man* is their favorite of my father's books. Burt Dow was a real person who lived here and sailed on one of the last working barkentines to go around Cape Horn. When Burt died, his friends got together and inscribed his gravestone, BURT DOW, DEEP WATER MAN.

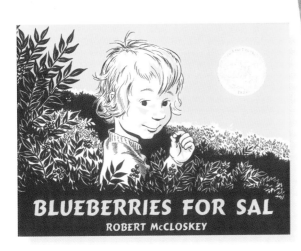

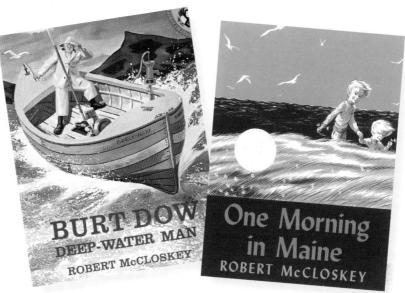

Bob also illustrated a number of books, including *Henry Read, Inc.* and its sequels, *The Man Who Lost His Head*, *Journey Cake Ho!* and *Yankee Doodle's Cousins*.

My father's increasing fame was part of our family life. People often asked me what it was like to grow up with a famous father. It was hard to answer, since I couldn't imagine what it would be like to have a different father.

But, perhaps because of his fame, or just his personality, my father was a very private and shy man. He didn't talk a lot, and when he did, he was often cryptic. Sometimes people approached him with an idea for a children's book, rather the way they approach lawyers about legal problems and carpenters about woodworking problems. His standard response to people who told him their ideas was: "Don't talk about it. Do it." He took his own advice.

As a result, much of my understanding of my father came from detective work, watching him and thinking about him and what he said and didn't say, and reading his books and looking at his pictures. This book is the result of a lifetime of sleuthing. It is dedicated to my father and mother with love.

Early Years

My father didn't talk much about his childhood. He did say that his uncle gave him piano lessons, which he hated, because when he made a mistake, his uncle rapped him on the fingers with a ruler. Bob discovered the harmonica on his own, and found it more fun. He got pretty good, and played in a band on a local radio station.

I knew his father worked for the can company in Hamilton, Ohio, but I learned the following from an article in a Hamilton newspaper, where they quoted a speech Bob gave. "And it was a white collar job. I know this because I had to take all those white collars to the laundry. The can company was involved in the vegetable shortening and illegal liquor business." In the same article, he said that kids didn't worry about playing in the street or getting hit by a car: "Those Model T's were high off the ground and didn't hurt much [if they hit you]. My cousin Irma was backed over by a Buick on Ludlow Street one day. She created such a fuss because her dress was torn that the Buick driver took her to a store and bought her a new satin dress." *Journal News*, Hamilton Ohio, 10.04.84, vol 60 No. 276 "Author Robert McCloskey Visits Hometown," by Ercel Eaton.

Bob said that when he was little, his family sent him with a wagon to pick up ice for the family ice box. He also took the wagon and a pitcher to the local brewer to bring back beer for the grownups. Bob told us that when he smelled marijuana in the 1930s when he visited the jazz clubs in New York City, he recognized the smell. His mother used to burn it as incense in the corner of his room to clear out his nose when he had a cold.

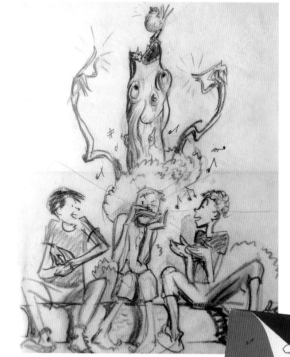

On weekends, Bob's father took him out to Bob's grandparents' home in the village of Millville outside of Hamilton, where he roamed the surrounding fields.

When Bob was a teenager, he went to a summer boys' camp for several years. After he died, Sal and I met men in Hamilton who had gone to camp with him. They described a full-size totem pole Bob had carved at the camp. It stood in the camp for decades until it became dangerous and was pulled down. Bob had never mentioned it.

Bob said that when he was older, he and a friend went to Canada in a borrowed Model T. When the radiator sprang a leak, they poured some oatmeal flakes down the spout. The hot radiator cooked them and they turned sticky enough to plug the leak.

My father's father's parents were deaf from scarlet fever. They communicated with hand gestures and occasional notes. His grandmother died of natural causes, but his grandfather was killed when he was

run over by a train. I must have learned about this accident as a young child from my parents, because I had nightmares for years that I was about to be run over by a train or truck, but I don't remember learning how my great-grandfather died until many years later.

Then I imagined that he was killed because he was deaf and could not hear the train coming. But just last month, my cousin Kathy told me he was rescuing a baby in a runaway baby carriage. He was able to push the carriage off the track, but was killed himself.

My father said that when he was young and trying to get established as an artist, he worked for a while drawing cartoons for a syndicated cartoonist. He also helped Francis Scott "Brad" Bradford paint six murals at MIT. As well, he painted watercolors in Provincetown on Cape Cod.

When Bob was about 25, he thought of doing a children's book with woodcuts based on the Norse story of Beowulf, with a Grendel monster looking ominous and wood-cutty. He brought some of his woodcuts to May Massee, the woman who was to be his longtime editor. She looked at his work and told him, "Lighten up. And go home and write about what you know."

So, he went back to Ohio. From his sketchbooks of this period, we can see that he spent some time at his old boys' camp, drawing his fellow campers and counselors.

Also during this period, he wrote and illustrated *Lentil*, his first book, about a boy who couldn't sing or whistle, so he learned to play the harmonica. I never heard my father whistle. He almost never sang,

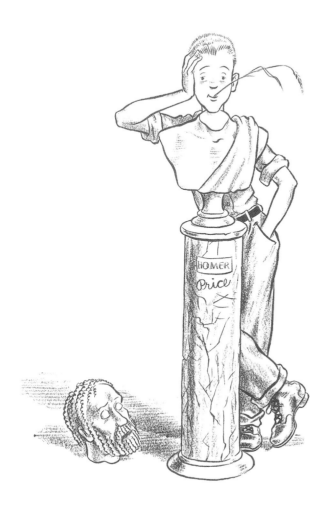

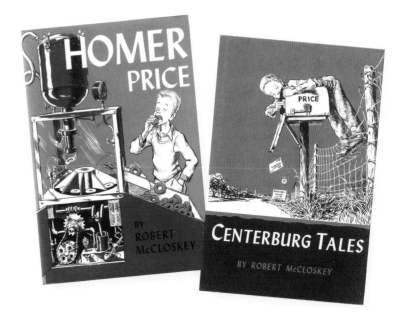

and he played a fine harmonica, so he must have written about what he knew. I have Bob's harmonica on a shelf in my office, and I take it out occasionally to play a couple of verses of "Oh Susannah," or "On Top of Old Smokey," and try that cupped-hand waver he did in the "St. Louis Blues."

In *Homer Price*, several years later, Bob wrote again of his boyhood in Ohio. In the frontispiece of the book, the head of the classical Homer has fallen off his pedestal, while Bob's live Homer Price stands behind the pedestal, stepping up to replace the original. Bob was telling May again that he had taken her advice about moving beyond the classics to find his own stories and characters.

May Massee was chief children's editor of Viking Press for many decades and was a major force in shaping American children's literature in the twentieth century. After May died, many of her illustrators and authors banded together to give some of their work in her memory to her alma mater, now Emporia State University. Emporia State has that work still, including the dummies for many of my father's books.

My Mother

My mother, Margaret Durand McCloskey, was born in 1917 to Dr. Albert Durand and Ruth Sawyer Durand. Her older brother was named David. They lived in Ithaca, New York, and had many friends who taught at Cornell University. Mom was called Peggy.

My grandfather was an eye doctor, and Mom said that during The Great Depression, the family never forgot that they were fortunate in having enough money to be secure. She said that many of her father's patients paid for his services with chickens or bread or vegetables.

Mom told us that they had a collie named Laddie. She said that there was no dog food when she was a child, and that Laddie ate what the family ate: meat, potatoes or rice or bread, vegetables, and maybe a piece of pie for dessert.

I am a little confused about my grandfather's history. He was the son of a farmer, maybe from Kansas or Iowa, or upstate New York. He became a doctor and enlisted as a medical missionary to go to China. I think that he was in China during the Boxer Rebellion, which was in 1899–1901. In any case, from his experience in China, he discovered that he did not like blood. He decided to become an eye specialist so that he would not have to deal with it.

My mother's mother was Ruth Sawyer. She came from a well-to-do family in New York City. Granny had an Irish nurse named Joanna, who told her stories from Ireland. I suspect that Granny was much closer to her nurse than to her mother, who was known as Cricket and was a delicate and impractical woman. Anyway, my grandmother fell in love with the stories of Ireland, and, working for the *New York Sun* around 1905, traveled to Ireland to hear Irish people tell their folktales. Later, she spent some years telling stories to children in the New York City Library System. Granny wrote a number of books, the most famous being *Roller Skates*, an autobiographical novel for young people about Granny's expanding and poignant life in New York City the year she received a pair of roller skates. *Roller Skates* won a New-bury Medal, which is "awarded annually by the American Library Association for the most distinguished American children's book published the previous year."

Granny also wrote another autobiographical novel, which was called *The Year of Jubilo*. In the 1890s, when she was about fourteen, her family lost their money in a financial crash and her father died. Granny, her mother, and her two brothers moved up to their summer home in Camden, Maine, while their New York home was sold for debts. Granny and her brothers throve on this simplified life. Her brothers took up haddock fishing and cut the twelve or so cords of wood needed to heat their house in winter. Granny became the cook and housekeeper, learning to make bread and trim the kerosene lamps. In summer, she walked all over the local countryside picking berries to sell in Camden. Granny's mother was less suc-cessful in making the transition, missing her husband and her New York City friends and lifestyle. The house they lived in is still off Route 1 in Camden, now a bed and breakfast called the Victorian by the Sea. My mother stayed in that house during the summers when she was a child.

My mother's childhood was pretty happy, except for a few troubles. She said that she was a smart kid and was put ahead two grades. She was able to keep up with her studies, but she was a little immature socially, especially when she got to her teens. She said that when she was fourteen, her mother went off to Spain to collect folktales, and Mom felt somewhat abandoned. She went bike riding in the Cayuga Gorge with friends and fell some distance and broke her hip. She was laid up for several months while she healed. It must have been a hard time to be without a mother. Mom also said that, because she had been put ahead in school, she went to college when she had just turned sixteen. She said she felt some-what insecure.

Because of family pressure, she went to business school after college, but then got up her courage to do what she wanted, and went to library school.

After she graduated from library school, my mother worked for several years in the New York City Library system. One evening, Viking Press held a cocktail party for their children's authors, and my grandmother, an established writer, was invited. My mother came along, because, as a children's librarian, she was interested in children's books and their authors. At the party, she met my father, who was a new protégé of May Massee, and the rest happened.

My mother continued to work as a librarian after my parents were married. During the war, they were posted to Anniston, Alabama, where Mom taught school.

In 1945, after my father was discharged, my sister, Sal, was born in Ithaca, and my mother retired from paid work to become a full-time mother. I was born in 1948.

The Island

After the end of World War II, my parents spent the summer of 1946 with my mother's parents in Hancock, Maine. Sally was just over a year old and I wasn't yet born. My father had never been to Maine before and he fell in love with it. He and my mother decided to buy a house there.

In *Make Way for Ducklings*, published in 1941, Mr. and Mrs. Mallard found an island home for their family in the Boston Public Garden. Bob must have been rehearsing how to find a home for his own family. While Mom stayed at my grandparent's home and looked after Sal, my father explored the Maine coast to find our island. Mom approved of his choice and brought Sally to their new home.

Later, Mom used to joke that they had moved onto the island on Labor Day, and had been laboring ever since. The island is beautiful, but it takes a lot of work to haul groceries, gas, suitcases, propane, library books, tomato seedlings, and everything else down the path to the dock on the mainland, down the runway to a float and onto the boat, off the boat onto our float, up the runway, onto the wheelbarrow or our own strong arms, and up the path to the house.

My parents planned to spend the first winter on the island, but the house was not winterized, and it got very cold in November. Mom decided that the island in winter was no place to raise a young daughter, so she took Sal back to spend the winter in Hancock with my grandparents. My father did not get on well with my grandmother, and he probably liked the challenge of living on the island in cold weather. That winter was more of a challenge than he bargained for. Penobscot Bay froze over for the first time in years—the last time it froze over ever.

When they reached the pond and swam across to the little island, there was Mr. Mallard waiting for them, just as he had promised.

The ducklings liked the new island so much that they decided to live there. All day long they follow the swan boats and eat peanuts.

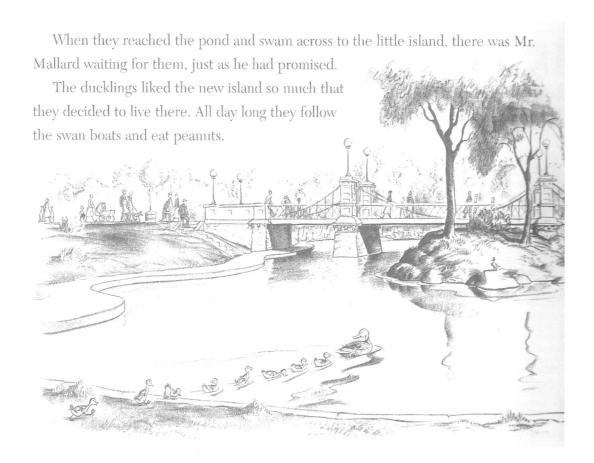

There is danger in walking on saltwater ice, because the tides dislodge the edges of the ice pack every day, and cause fissures and weak spots all through the ice. Local people had learned to nail boards on the bottom of a rowboat to act as sled runners, and push the boat in front of them across the ice. If they came to open water, they jumped into the boat and rowed across the water to the ice on the other side, jumped out again, and started pushing. If the ice broke under their feet, they could jump in the boat and stay safe.

My parents agreed that my father was to call my mother once a week on a certain day. So, one day, even though it was snowing, Bob set off across the ice to Little Deer Isle and a phone. He had to push the boat through knee-deep wet snow, a tiring process over a quarter mile of ice. Because of the snow, he could not see the weak spots in the ice. When he neared the far shore, the ice broke, and he fell in to above his knees. He jumped into the boat, but the damage was done. In winter in Maine, if you aren't out

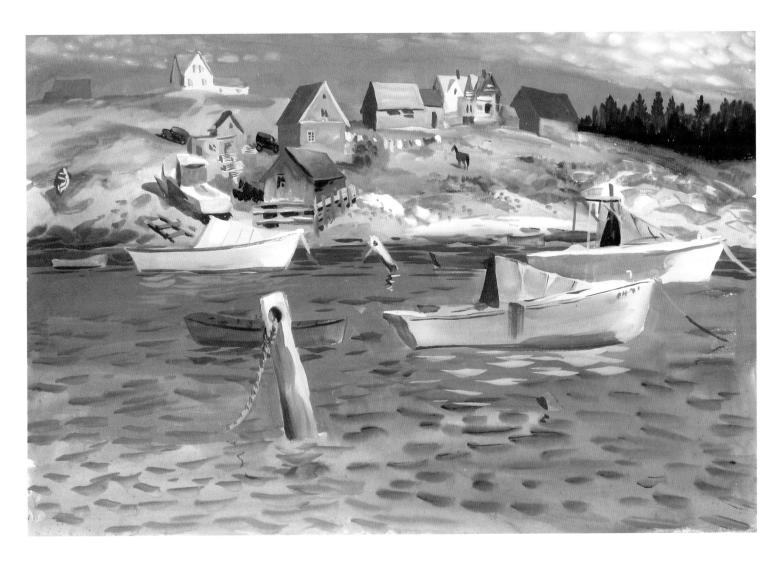

of the water in minutes, you die of hypothermia. Even just wet to his thighs for a few seconds, my father was pretty cold. He had to walk through a mile and a half of deep snow to reach civilization. Years later, when he told me the story, he said he was pretty relieved to see Walter Douglas's store.

But the bay was not always frozen. In the fall and spring there was open water, and he made the trip to Buck's Harbor once a week to make his phone call to Mom and to buy gas and groceries. I think he was also glad to visit with people on the mainland. It must have been a little lonesome starting back on the boat trip home.

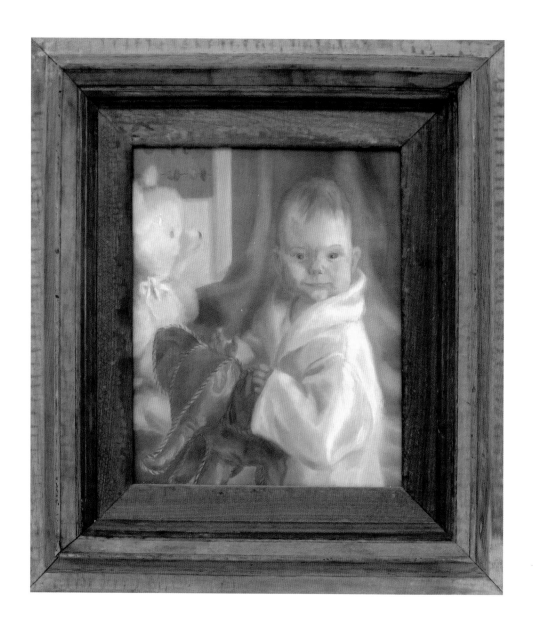

Artist's Daughters

Bob said that when he was illustrating *Make Way for Ducklings*, he kept four ducklings in his bathtub. He sketched them in various moods: happy, scared, and bored. He did the same with Sal.

Sometimes, my mother sent Sal and me to visit my father at his studio in the boathouse. The studio often had paintings we had never seen before, and sometimes never saw again until after he died. After we looked around for a few minutes, Bob arranged us on the floor with chalk or pencils or paint, and we all settled down to work. If the weather was cool or rainy, we were cozy with a fire in the barrel woodstove. While Sal and I were working, my father sometimes drew us. Many of these sketches were done from the side or back-side-to, so as not to distract us.

Usually, my father drew us when we weren't aware, but when we got a little older, he occasionally asked us to pose. Posing was a grownup responsibility, and we got paid a dime for each session. I was proud to pose, but it was hard to sit unmoving for minutes at a time. When Bob gave us a break, we got to see the sketches he had made. This one is of Sal.

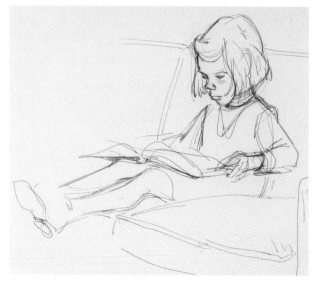

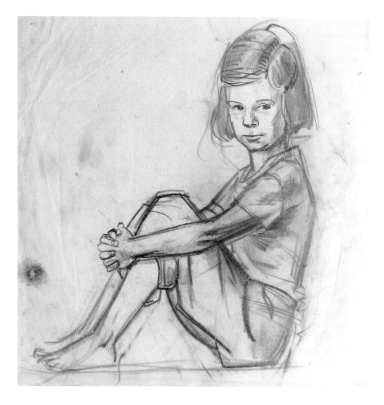

This sketch of me was done before I had figured out I was left-handed.

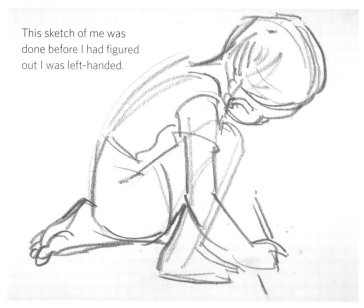

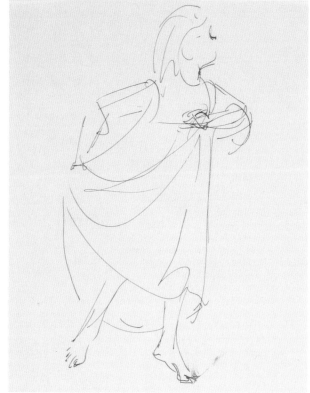

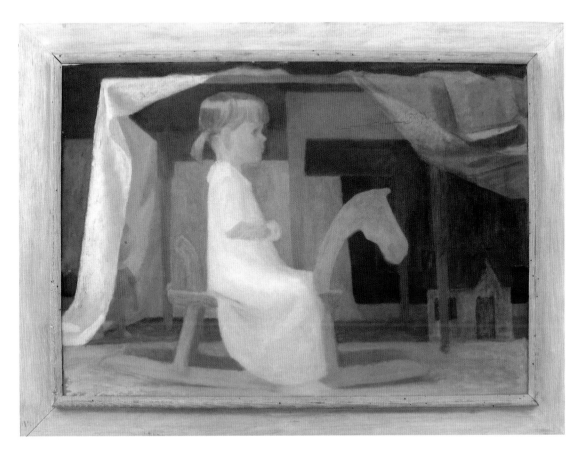

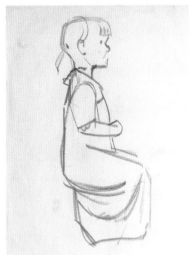

With some sketches, I can't remember or tell if they were posed or not.

The sketch I remember best happened one evening in winter during my parents' cocktail hour. I was in front of the fire, rocking on a horse that came from Italy. I faced my father, who was in an armchair about five feet away. Suddenly he looked at me and said, "Jane, would you please put the rocking horse in front of that table over there?" I did, and he asked me to turn it sideways. He looked for a moment and then got up and positioned the horse the way he wanted it. "Can you rock there for

a bit? Is that okay?" he asked. I said yes. "I'll get my sketchbook," he said. And he drew me.

This sketch became my favorite picture of me.

The last sketches Bob made of me were for *Henry Read's Baby-Sitting Service*, when I was about fifteen. I posed as a stuck-up girl at a picnic.

Time of Wonder

On drizzly or foggy days, when we were young, Sal and I played with blocks or Tinkertoys or dominoes, or drew or cut out paper.

Sometimes Sal wanted to read, and I got bored and pestered her.

Occasionally, on wet days, my father made a fire on the beach to burn the excess driftwood at the high tide line. He also burned brush left from trees that he or the Cliffords, our caretakers, had cut near the house and boathouse.

After Bob got the fire going, he rousted us from our books or games, and Mom from her housework or deskwork, and we trooped down to the boathouse beach to spend a couple of hours dragging wood and brush to the fire. We watched the sparks fly up, and felt the welcome warmth. We stood around the fire as the pile burned down, and then went to haul another load of wood.

Sometimes, Mom disappeared and brought down some hot dogs and rolls, which we roasted on the fire. Then we hauled some more brush and built the fire back up again. When the fire died down, my father raked together the outlying bits of wood so they would burn. He stood watch, while the rest of us went back to the house to change out of our wet clothes and make tea. He came in later for a quick cup, and then went out again to check the fire. He always made a last check to make sure that the tide came up to cover the ashes.

My parents did not make a big deal about it, but we knew from an early age that there was no fire department or handy doctor to help us if we got into trouble. We learned to be cautious and assume that, on the island, there might not be any help available except each other.

Sometimes our family walked around the woods trail that circled the island. We had to climb our way around several trees that had fallen in recent years. Bob said that in the old days, the previous owners had lots of money, and had all the fallen trees cut up every year, and the island raked from one end to the other. He said that we couldn't afford that, and in any case, it wasn't good for the woods, which needed most of the fallen branches and needles to replenish the soil.

In high summer, we found chanterelles on our walks, which we brought home. Mom fried them in butter.

Sometimes, when there was a full moon, Sal and I got up shortly before six o'clock in the morning and went down to the shore. In the early morning, the sunrise was just beginning to burn off the morning mist.

On the day of the full moon, the tide was especially low. The sandbar between our island and the little island emerged from the water, and we could walk across to the other island. The bar was only uncovered for about half an hour, so we knew we had to stay on the bar itself and not try to explore the little island. We had to get back to our island quickly when the tide started coming in.

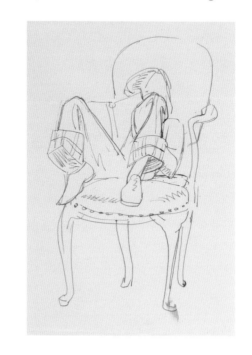

On the sandbar, we saw creatures we did not usually see uncovered by the water: sand dollars, large whelks, pink "picky toe" crabs, six-inch eels, thin-legged brittle starfish, small scallops, quahog and razor clamshells, and

sea anemones. There were skate eggs that looked like a cross between Mom's nutmeg grater and a horseshoe crab. We knew the names of all these creatures because Mom had studied zoology in college.

Sometimes my sister and I visited back and forth with friends. My earliest friend, Edee, lived in a cove on nearby Little Deer Isle. There are pictures of her and me sitting on the beach naked when we were one year old. When she came over to play, our favorite game was wild horses. We ran and pawed our hooves on the ground, ran and tossed our manes, and ran some more. We pricked up our ears when men tried to catch us, and ran away again, over the beach to the rocks, out to the point, and back again. We hid in the woods, and we turned our hind legs out to kick at the wolves that menaced us. Sometimes we just grazed quietly in the sun.

One of the obvious aspects of living on an island is that you can only get there by boat. From my youngest years, I remember the boat trip from Cape Rosier to our island. It was usually a beautiful time, with golden afternoon sun, and light winds on the water. The boat engine was a steady grind that wrapped us in hypnotizing sound.

Sometimes when the weather was blowing, the crossings were rough. I went below into the cabin, where I curled up in a nest of life jackets, covered by a wool plaid car blanket. Through the cabin door, I could see Mom in her director's chair. When it got rough and the chair threatened to tip over, she stood up and held on to the counter of the upper cabin. I could see her swaying with the pitch of the boat. A little blow didn't worry my parents, so I learned to trust that probably nothing would happen to us.

Occasionally, it was so rough, my parents got worried, too. One day, Mom was hanging on to the counter. My father was out of sight at the wheel, and Sal was also out of sight, sitting on the engine box between my parents. I came from below to see the huge waves and boiling foam. The engine revved and growled, depending on how the waves were hitting the propeller. I could feel the wind and spray on my face. The deck sometimes dipped below a wave, and water rushed along the deck back to the stern, sloshing some into the cockpit. Everyone held on.

After a bit, I went back down below again. In my family, it was my job as the youngest to keep quiet and let them cope. Sometimes my sister also had that job, but she didn't always do it as well as me. It was her job to cope when my parents weren't there, and she usually did that very well. Mom taught us how to row our dinghy, the small rowboat we kept on the dock. We put on our life jackets and pushed the dinghy overboard. Mom sat in the stern seat and I sat in the bow. Sal sat in the middle, took the oars, and rowed us around the island. When I got a little older, I got to take the oars.

We had a small sailboat that was stored in the boathouse over the winter. In early summer, we all sanded and painted the white hull and red bottom of the boat. My father rigged the sails and lines. Then, at high tide, we put planks and pipe rollers under the boat so we could roll it out of the boathouse to the beach and into the water. While Bob watched from shore, we paddled the boat into deeper water. Mom put down the centerboard, raised the mainsail, and took the tiller. Sal raised the jib, while I held the jib sheet rope, and off we went. When Mom said, "Ready about. Hard. Alee." I let go of the jib sheet on one side, and Sal pulled in the jib on the other. "Jibe-ho!" meant "Duck!" because the mainsail boom was going to come across the deck fast and hit your head if you didn't get out of the way. On my sixth birthday, Edee was supposed to come over to visit. She didn't actually come, because my father decided it was too windy and rough to bring her across in the boat. I remember my disappointment, and the consolation that my mother had made a delicious cake with apricot filling. I liked it so much that she made me that same birthday cake for many years.

Edee was a wild person when she was young. She was a little thing, but she bossed me around "something awful," as they say around here. I loved to play horses, and she did too, but she also loved to play fairies. I don't remember that we followed any particular script. The game was about hierarchy and being bad. She was the Black Fairy. She said her friend Dink in Atlanta was the Red Fairy, who was almost as bad (good) as the Black Fairy. But I was the White Fairy. She made it clear that I was a wimp. I guess I was. If she was feeling generous, I became the Blue Fairy.

Edee and I used to spend the night at each other's houses. As we got older, sometimes when she came over to my house, we went

camping. At first, we took our sleeping bags out to the point and slept on the hard rocky ledge. When we got older, we rowed over to Pickering Island, where we carefully lit a fire, cooked our food out of cans, and suffered mosquitoes. There was a story that in the early 1900s, there had been a hospital on Pickering Island. It was said that the doctor who ran the place was known to get rid of some of his patients if their families wanted them gone. My friend Bill, who is an anthropologist and an authority on local history, says that the mental hospital really existed, but that the murders never happened. Edee and I had a great time thinking of scary times of long ago.

At Edee's house, her father was usually gone to do his job reporting for *Time* magazine. Edee's mother was a gentle, romantic woman. She went down to the shore every morning to swim and brush her teeth in the salt water. She said salt water was healing, and she even ate kelp from time to time. She found Indian arrowheads on the beach, and helped us imagine the Penobscot Indians who once walked the paths of what was now the family land.

She paid us a dime for every cup of blueberries we picked. This was good pay, since we could pick a cup in ten or fifteen minutes. Then we took our money up the long half-mile drive to the paved road and on to Walter Douglas's Store, where we bought red licorice and peanut butter cups.

Back on the island, I was learning about the weather. From a very young age, I learned that weather was associated with the wind direction. Southwest winds brought warm, sunny weather, and usually moderate breezes. Southwest winds were the usual winds of summer. Light southeast winds usually brought fog, and strong southeast winds brought rain and storm. Northwest winds brought cold, crisp, clear, beautiful days, with strong winds and rough water. Northeast winds meant storms.

In 1954, when I was six years old, Hurricane Edna hit the coast of Maine. Edna was the hurricane Bob wrote about in Time of Wonder. We did sit on the couch singing with Mom, so we wouldn't get scared, while Bob put towels against the French doors and prowled around the house to keep an eye out for trouble. In the eye of the hurricane, when the wind calmed, Bob took us out on the front lawn. The water was usually about sixty feet from the house at high tide. Now, great waves rolled up the lawn to about fifteen feet from our terrace. We went back into the house, and the storm returned. Mom read Davy and the Goblin to us, which was a distracting scare from the fright of the storm. Then a tree fell on the roof with a boom! but the house stood firm. We had ten-by-twelve beams supporting the roof.

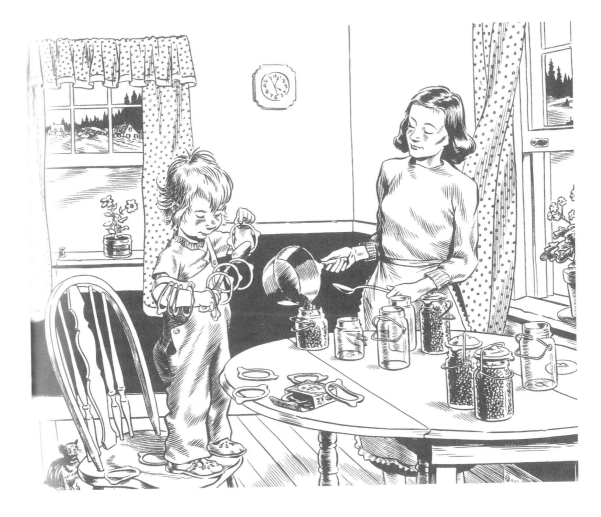

In the morning, we went out to see the huge tree on the roof. There was an inch of water on the lawn, and three trees had fallen across each of the two paths to the boathouse and dock. Soon after the storm, we left our island in Maine for Croton Falls, New York, where we spent winters in May Massee's summerhouse. Hurricane Edna had hit all of New England hard. In Connecticut, we went on detours on top of detours, and once, even a detour on top of the second detour. At one point we drove through an underpass with water up to the car floor before we made it safely to our New York home.

Over the winter, while we were in New York, a lumber company cut the trees the hurricane had blown down on the island and took them on a barge to the Bucksport paper mill for pulp. The vanished trees

allowed in sunlight, while the brush left behind broke down into the soil. A couple of years later, these areas filled up with raspberry bushes. When I was little, we went picking with Mom, but when I was older, I also went by myself. We had fresh raspberries with cereal or cream. Mom made raspberry sherbet, raspberry ice cream, and raspberry jam. Occasionally, she made raspberry pancakes, which were delicious, but seedy.

My parents had a pretty traditional way of dividing the family chores. My father made the money and took care of the car. He talked to the Cliffords about care of the boat and dock, the generator, and other equipment. Mom took care of the kids, cooking, housekeeping, and gardening. She also wrote and typed most of Bob's correspondence, which he then signed. They conferred over lunch about what the letters should say. She also kept the accounts, did our income taxes, and generally kept our official life in order.

This division of labor worked pretty well, except that my father thought that keeping the kitchen knives sharp was my mother's responsibility, since knives were part of the kitchen. My mother thought that keeping the kitchen knives sharp was the husband's responsibility, because her father had always sharpened the knives when she was a child. As a result, our knives were usually somewhat dull, but that didn't affect Mom's cooking. I myself prefer somewhat dull knives, maybe because I am used to them. I am less apt to cut myself.

In the summer, Mom grew a vegetable garden with beans, carrots, lettuce, scallions, zucchini, tomatoes, and broccoli. She experimented with New Zealand spinach, Swiss chard, Brussels sprouts, patty pan squash, peppers, and yucky arugula. She didn't grow corn or peas or potatoes, because she said they took up a lot of space, and we could get them from the Cousins's farm on the mainland. When we planted the garden, we helped Mom stretch the string between stakes at each end of the planned row, so the rows would be straight. We pulled a rake handle through the soil next to the string to make a trench to put the seeds in. Then we planted the seeds and stamped down the earth with our bare feet.

Mom also grew flowers. I liked the irises, snapdragons, and tiger lilies. I didn't like petunias, because one of our jobs was picking off their sticky dead flowers. Mom gave Sal and me a rock in the rock garden to care for, and we spent many hours grubbing in the dirt. Mostly we uprooted clumps of sedum, pulled out the grass, and replanted the sedum on the rock.

My mother was a good cook, more sophisticated than most American cooks of her time. When our family went to Italy when I was a baby, my mother learned the flavors of Italy, and she brought back cookbooks in Italian and French to Maine. She routinely used garlic and thyme, rosemary, and oregano. She used to have to buy all the garlic we would need for the summer in New York and bring it up with us, because they didn't sell fresh garlic in the local Maine stores. We had what they now call vinaigrette every night for our salad at dinner. We called it salad dressing. She was also unfortunately ahead of her time in her choice of greens. When Sal and I were in our teens, we began stumbling over arugula and borage blossoms in the salad.

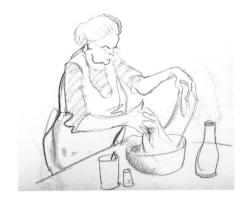

Mom made bread often: loaves for toast and sandwiches, long French loaves, and individual rolls for dinner. Before most people began worrying about nutrition, she began making half her loaves with half white and half whole wheat flour. I believe that this picture is of my father's grandmother making bread.

One of our great meals was lamb shish kabob, marinated all day in oil and wine, onions, rosemary, green peppers, garlic, and salt and pepper. After they soaked, she put the lamb and peppers on skewers with tomatoes and more onions, and Bob cooked them on the grill in the fireplace on the terrace.

In One Morning in Maine, Sal, Bob, and I all came home to clam chowder for lunch. In reality, it was more apt to be clam spaghetti. Bob and sometimes Sal and I would go out and dig clams in the morning.

After Mom steamed the clams, she and Sal and I removed them from their shells. Mom sauted garlic in butter with parsley, added the garlic butter, clams, and some cornstarch to the clam broth (not too much to make it gooey), and then cooked the spaghetti, al dente of course. Salad, and that was lunch.

If Mom made chowder, it was usually a medley of leftover lobster (she bought an extra for the purpose), mussels, and maybe some fish. She started with onions sautéed in butter, and lobster broth and seafood added, potatoes cooked and added, and milk added at the last minute, when the mixture wasn't

too hot so it wouldn't curdle. And parsley. Today Sal follows many Deer Islanders who use bacon to boost the flavor, which is also excellent, but Mom rarely did.

Mom made mussels Porta Veneri, with tomato sauce and served in bowls over stale bread. She was thrifty and good at using leftovers. In fact, I think it was her ability to make good food out of what we had, rather than buying stuff for one sumptuous meal, that made her such a good cook. I remember being surprised when I grew up to hear other people putting down leftovers, as if they weren't as good as the original dinner. I always thought that the soups and rice dishes, noodle dishes, meat loaves, and croquettes were as good or better than the original meal.

Mom made tamale pie from cooked cornmeal spread around the edge of her pottery paella dish. She sautéed hamburger with green peppers and onions, added tomato sauce and (in those days) canned black olives, added Tabasco sauce, and put it all in the paella dish, with grated cheddar on top. Then she baked it in the oven.

She made minestrone, soaking kidney beans overnight and cooking them up in the morning, sautéing hamburger and putting it in the soup pot, and then adding all the vegetables available: onions, green beans, peas, zucchini, tomatoes, corn, garlic, oregano and thyme, and then, glory, noodles. She served it to a large crowd for fall lunches, along with homemade bread and salad from the garden.

Mom wasn't big on desserts, but when we had company, she sometimes made a pie. If it was just the family, she occasionally made Apple Brown Betty, which I actually preferred.

Several times each summer, she deep fried zucchini, slicing them and drying the slices on a cloth for several hours. Then she dredged them in flour flavored with rosemary and salt, and dropped them into a strainer in the hot fat. Zucchini was the only thing Mom was willing to deep fry.

She also made fried squash blossoms. She stuffed the blossoms with a combination of mozzarella and cheddar, and sometimes added pepperoni or anchovies, too. She made a sugarless pancake batter and dipped the stuffed blossoms in the batter and fried them. Friends cringed when they heard we were going to eat fried squash blossoms, but most became enthusiastic after one bite. Mom kept the anchovy ones separate so no one got one by mistake.

Mom marinated green beans with a regular salad dressing of oil and vinegar and garlic.

I learned these recipes from her. There were others I liked but not enough to get around to learning: soufflés, spoon bread, paella, gnocchi, pies. She made a few things I disliked: pot roast, jellied fish stock, ceviche (marinated raw fish), and chestnut and oyster stuffing. She always cooked pork chops until they dried out, because she worried about trichinosis.

If Mom burned food, which happened rarely, the odds were that she was mad about something.

Sometimes we went on a picnic to the little island. Mom made sandwiches. Chicken or tuna salad, or ground up leftover lamb with mayonnaise and onions, or maybe a surprise of cream cheese and olive. Hard boiled eggs, or if we were lucky, they were deviled. All were wrapped in wax paper. Salad, maybe a watermelon. Bob anchored the powerboat off the beach, and we rowed ashore in the dinghy.

After lunch, we had to wait half an hour before we went swimming, so we wouldn't get stomach cramps and drown. I remember when I could not swim, so I put my hands on the bottom to pretend I was swimming. My parents showed me how to kick my legs and move my arms and dog paddle for real. Sometimes Mom made me come out of the water, because she said I was turning blue. Sal got to be a pretty good swimmer, but I am one of those who sink if they aren't in constant motion, so I find swimming more effort than it is worth.

When we were little, before we went to bed, Sal and I crawled into my mother's bed on either side of her, and she read to us. Wind in the Willows was pretty dull. The Just So Stories were pretty good, especially the story of Dingo—Yellow—Dog Dingo, and Old Man Kangaroo. I loved The Jungle Books, The Princess and the Goblin, The Princess and Curdie, The Silver Curlew, The Glass Slipper, and many of the fairy tale books given to us by my mother's mother. When we got older, my mother read to us on the couch.

I didn't learn to read until I got to first grade. Once there, I was introduced to phonetics, and learned to read in the first month. After that I read almost anything. When I was seven or eight, we became members of the Blue Hill Library, and stocked up on library books when we went to Blue Hill. For years, my favorites were horse and dog books. I got to begin reading on the boat trip home, with a blanket if it was cold, cuddled in the life jackets. My favorites included Call of the Wild; Lad: A Dog; Lassie Come-Home; Black Beauty; The Black Stallion; My Friend Flicka; Green Grass of Wyoming; Thunderhead; Man O' War; and The Incredible Journey.

We had several dogs of our own. First we had Penny, an English Setter who died when I was about seven. Then we had Tuppence, another English Setter, who ran full speed into the wheelbarrow and damaged his brain. He died a year later of neurological problems. Then we got Finny, who was the first dog I truly loved. This is a picture of Finny, who loved to shake hands. Before I knew how to read, I pestered my sister to play with me when I was bored. Once I started reading, I was rarely bored again. Sal became more friendly once the pressure was off, and we spent a number of years in pretty good harmony, playing cards, jacks, pickup sticks, and Monopoly, and doing jigsaw puzzles. We swung on the trapeze my father made for us, walked to the boathouse on our stilts, and dug sand on the beach.

In the evening, while Mom was cooking dinner, my father turned on the generator so that he could turn on the radio for the news and weather from WRKD out of Rockland. Many years later, I realized that RKD is pronounced Arcadie, the French-Greek word for rural paradise. Several sites on the Internet also say that Cadi (Quoddy) was the old Mi'kmaq Indian name meaning "place" or " place of plenty." The meanings of Arcadie and Cadi seem to have been combined in the word Acadia which refers to Maine and the Maritime Provinces. Acadia National Park is on Mount Desert Island.

Some evenings, if I still had a lot of energy, my father would suggest that I run around the house three times without thinking of a fox. I took this problem seriously and still do. I ran around our house a lot of times.

After dinner, Mom and Sal and I sometimes played Scrabble. Bob often went back to the studio for another work session. Sometimes, Mom persuaded Bob to play poker with us after dinner, using wooden kitchen matches as poker chips. When Sal or I won, which was often, Bob called the winner the Little Match Girl. I learned later, when I read Hans Christian Andersen, that the original Little Match Girl was not a rich little girl who had won all the matches, but a poor little girl who had to go out in the freezing winter streets to sell matches. She froze to death and was taken up to heaven by her grandmother.

Sometimes after dinner, Sal and Mom and I sang. Mom taught us many British songs: "Greensleeves," "Drink to Me Only with Thine Eyes," "Foggy Foggy Dew," "Loch Lomond," "Coming Through the Rye," "There Is a Tavern in the Town," "Eddystone Light," "Blow the Man Down," and "Walloping Window Blind." Sometime Bob played the harmonica while we sang. Then we played American songs: "Camp Town Races," "Oh, Susannah," "Careless Love," "Coming Round the Mountain," "St. James Infirmary," "Swing Low, Sweet Chariot," "I've Been Working on the Railroad," "Erie Canal," and "Mine Eyes Have Seen the Glory." Bob wound down with a solo of the "St. Louis Blues," and then it was "Good Night, Ladies," and Sal and I went off to bed.

Occasionally, my parents went out at night. Instead of bringing a babysitter to the island, they took Sal and me to the Cliffords on Cape Rosier to spend the night. For many years, the Cliffords had run a small summer boarding house for "rusticators." In time, many of their guests had bought land and built houses in the area and become summer people. Summer boarding houses had now gone out of fashion, and the Cliffords rarely had guests when I was a child, but Mrs. Clifford fed us as she used to feed her rusticators. For supper, we had mashed potatoes or corn, green beans or peas or carrots, and tomatoes—all from Mrs. Clifford's garden. We had chicken or pork or beef, and baking powder biscuits or homemade bread. For dessert, we always had pie or frosted cake, which were treats after Mom's restrained desserts.

The Cliffords ate at about 5:00 in the evening. They also had a TV, so after dinner, we watched the weather and news, and ended with Dragnet: "Just the facts, Ma'am." It was now 9:00, so we had another slice of cake or pie to hold us over until morning. Then, along with everyone else, we went off to bed. The upstairs was not wired for electricity, so we carried flashlights up the stairs to our rooms.

We ate breakfasts of sausage or Canadian bacon (Mrs. Clifford was from Nova Scotia) and had our choice of French toast or waffles or pancakes or eggs any way we wanted them, and cereal and baking powder biscuits or toast or blueberry muffins. Mrs. Clifford cooked on a woodstove in the kitchen, which got pretty hot. Also in the kitchen was an old-fashioned crank wall phone. They were on a party line with eight other houses, and had to talk to the operator to make a call.

Ferd Clifford kept a cow until I was about six, but with fewer guests the cow became a luxury, and he sold her.

There were still barn cats, and wild kittens. One morning I awoke to see a kitten on the windowsill (the screens had not yet been put up), looking at me in terror. The next second, the kitten jumped onto the wall and, still halfway up the room, climbed around the corner to the wall behind my bed. Then she crawled behind me around another corner until she reached the door to the hall, where she finally dropped to the floor and ran through the open crack. This performance so astonished me, I almost expected the kitten to fly. My father said that Mrs. Clifford had put so many coats of wallpaper on her rooms, the kitten could hold on by sinking her claws into the layers of paper.

When we got a little older, my parents sometimes took us out at night when they went over to friends for dinner. Coming home at night was often wonderful, with millions of stars in the dark sky, and phosphorus sparkling in the calm water. Sometimes there was a moon shining on the black water. The wind usually died in the evening except during storms, and then we didn't go out in the first place.

Still, fog often came in at night. I was scared of rough water, but fog was nerve-racking even for my parents. We had a compass, but at night it was hard to read. My father held the flashlight in one hand, which reflected off the compass glass. He steered with the other hand. When my father used the flashlight to see the compass, he had no night vision. He had to depend on Mom and Sal and me to report islands or rocks or logs ahead. We strained and strained to see into the dim dark, until darker shapes loomed out of the white mist. We always made it home, but it was always tense. My father, unlike his normal self, was like an army officer, commanding dowsed lights and silence.

One day, Mom and Granny took Sal and me to Ellsworth to get our second polio shots. They dropped us off at the doctor's office while they did errands. When the doctor gave me the shot, I immediately felt awful. I had felt nothing like this after my first polio shot. I lay down on a bench until Mom and Granny picked us up.

We had lunch at the Hancock House, an old-fashioned hotel in Ellsworth. I felt somewhat better and ate part of a chicken sandwich. On the way home, I started feeling sick to my stomach and told my mother. She said, "Hang on, Jane; we will be home soon." She talked to Granny, and they decided we wouldn't pay a call on E. B. and Katherine White in nearby Brooklin. Granny was an author and knew them. I felt too sick to be disappointed. I complained again to my mother, and she soothed me that we would soon be home.

I threw up on my grandmother's legs. In a kind voice, Mom boomed, "Good job, Janie!" She was probably glad it wasn't her lap. Mom stopped the car. Granny took off her stockings and cleaned herself, while Mom cleaned up the car.

We never did get to see E. B. White. (They called him Andy White around here.) My father usually wasn't comfortable with strangers visiting him, and he figured the Whites felt the same way. We went to see the Whites another time when Granny visited us, but they weren't home. At that time, I had only read

Charlotte's Web, which I liked pretty well. When I was twelve, I read *One Man's Meat*, and *The Second Tree from the Corner*, and they became two of my all-time favorite books.

Bob quit smoking cigarettes when I was about eight, and took up a pipe. Mom didn't approve of the pipe's smell. Bob explained gravely that the reason the pipe smelled bad was that Herman washed his dirty socks in the bowl. He said that Herman's wife didn't like the smell either. Herman must have been pretty small to wash his socks in a pipe bowl.

Some days, when he was edgy or irritable, my father would look apologetic and say, "I'm sorry. I have Little Men after me." A few years later, I read "The Fairies" by William Allingham.

Up the airy mountain
　Down the rushy glen,
We daren't go a-hunting,
　For fear of little men;
Wee folk, good folk,
　Trooping all together;
Green jacket, red cap,
　And white owl's feather.

One summer, we made root beer, using a mix made by the Hires Root Beer company. We added water, yeast, and sugar, used a funnel to pour the mixture into quart bottles, and used a bottle capper to cap them. We put the bottles in the basement and left the yeast to work. A few bottles exploded, but no one was there to be hurt. Several weeks later, the root beer was ready. It was delicious, and lasted us the rest of the summer. The next year, Mom said that root beer had too much sugar for root beer making to become an annual tradition. Maybe she also had second thoughts about those exploding bottles.

My parents liked to watch birds. When Mom planted bee balm in the garden, they discovered that this plant was a great favorite with hummingbirds. A friend of theirs smoked expensive cigars that came in metal containers, which he left behind after a party on the island. Bob fitted the containers with holders to hang on the bee balm plants, and Mom kept them filled with sugar water. One time we had a treasure hunt. One of the clues was "The Hummingbird Restaurant," which was, of course, the bee balm patch

with the sugar water cigar cases. Mom stopped the feeding after a couple of years, because she said that sugar probably wasn't any better for hummingbirds than it was for us. The hummingbirds continued to visit the bee balms anyway.

On any sunny day in summer, bumblebees zoomed around the flowers in the garden. Mom punched holes in the top of a mayonnaise jar and sent us outside. We approached a bumblebee on a flower, held the jar mouth beneath the flower, and used the lid to brush the bee into the jar. We liked to see how many bees we could catch. After four or five bees, they started escaping when we opened the lid to catch the next one. That kept us amused for about an hour. I only got stung once every couple of summers. Mom put baking soda on the stings.

One day at lunch, when I was about nine, my father said he had seen a white hornet that morning. Mom said she had seen a couple around the garden in recent days. They explained to Sal and me that these white hornets looked like yellow jackets, but they were much bigger—bigger than a wasp—and had a bad sting.

I was picking raspberries a few days later when I saw a white hornet on a berry. It was big, about twice the size of a wasp, with handsome white stripes. Then I reached underneath a clump of leaves where the biggest berries sometimes hid, and another white hornet lumbered away like a bumble bee. Then I saw the edge of a huge grey wasp nest in the canes about three feet from me. I froze. I yelled. "BOB! BOB! BOB!" I had never yelled like that before.

About two minutes later, my father came running from the boathouse studio halfway across the island. He moved faster than I had even seen him, and came to a stop about fifteen feet away from me. He found out the trouble, and walked carefully closer until he could reach out and lift me high over the raspberry bushes. He swung me around to safety. The two hornets had disappeared by now, and when he looked for the nest, there was none. It was a false alarm, but the feeling of safety and love I felt from him has remained with me always.

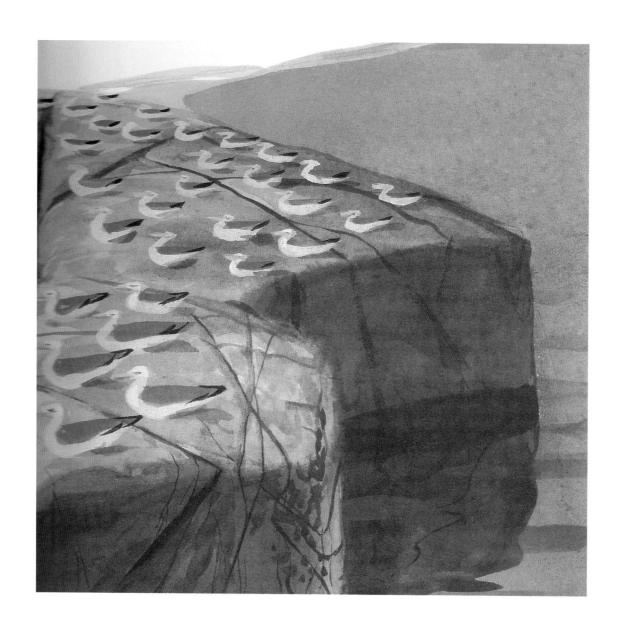

My Grandparents at Gull Rock

Sometimes my parents went away for a few days and left Sal and me with my grandparents at their home in Hancock. My grandparents had named their place Gull Rock, after a ledge that lay in the tide flats off their beach. When we stayed with Granny and Grandad, we picked cultivated raspberries with Grandad in his garden, and wild blackberries with Granny on the driveway. Sometimes we went with Granny to a neighbor's to pick blueberries, but we never saw a bear.

We played on the huge anchor on the lawn. Grandad said that the house had belonged to a sea captain, and the anchor reminded him of his seafaring days. Sometimes, when Granny sewed, she gave us cloth to practice our stitches on. She taught us not to make big gobble stitches, even though they gobbled up the cloth and made the work go faster. Granny made handsome bathrobes for Sal and me: pink for her, blue for me.

One time, when my parents left us at my grandparents, Sal persuaded me to walk out to the ledge at Gull Rock. We had never been there with my grandparents, so I was doubtful. It looked like it was a long way away. Sal teased me for being a scaredy cat. It was just like walking to the little island on the sandbar at home, she said.

We put on our boots and set out. At first it wasn't bad, but soon the sand turned to muck. At first, we could pick our way by stepping on the clumps of mussels, but after a bit, the mussels that supported us grew sparser. I was getting frightened and started crying. Sally called me a scaredy cat again. I kept on. The muck became deeper, and my boot came off.

Little Bear's mother turned around to see what on earth could make a noise like *kuplunk!*

"*Garumpf!*" she cried, choking on a mouthful of berries, "This is not my child! Where is Little Bear?" She took one good look and backed away. (She was old enough to be shy of people, even a very small person like Little Sal.) Then she turned around and walked off very fast to hunt for Little Bear.

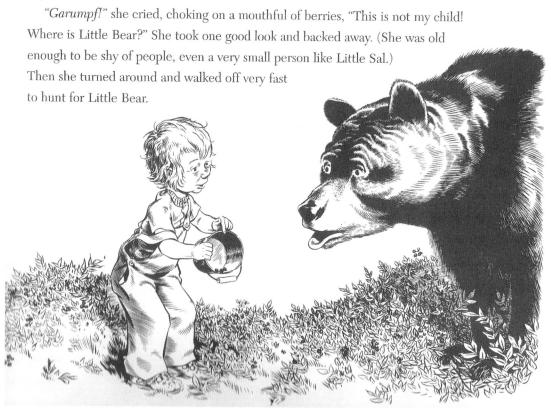

I was grateful to hear a yell, and turned to see Grandad striding across the field to the shore in his hip boots. When he reached us, our gentle Grandad gave us what for. He put on my boot, lifted me up on his shoulders, and carried me back to the field, with Sal in tow.

We were in disgrace for a day. My grandparents told us that there was quicksand on those flats going out to Gull Rock. They also said that the flats were so flat, and the tides there so extreme, that when the tide came in, it came in very quickly. We could have been drowned. Granny fed us bread and water for lunch and dinner, and again for breakfast the next morning. Actually, it was buttered homemade bread and water, so we didn't suffer much After discussing the matter, they even toasted our bread for breakfast. Still, we were very ashamed of ourselves.

It seemed that we were at my grandparents for a long time that summer. Maybe the reason Sal led us out on the mudflats was because she was bored, or maybe she was mad at my parents for leaving us so long. I think of this, because there was another time Sal was left too long at my grandparents.

During World War II, my father won the Prix de Rome, now called the Rome Prize. The Prize was a year's scholarship to study at the American Academy in Rome. Since Italy was under Fascist control during the War, the scholarships were postponed until peace came, and the Academy had recovered enough to reopen. They wrote to my father in the summer of 1948 that his scholarship year began in September.

My mother was pregnant with me and due in September. They had three months to pack for Italy, planning for a newborn baby and a child of three in a foreign country still recovering from war. Toward the end of her pregnancy, my mother and Sal went to stay on the mainland in Hancock with her parents, while my father stayed on our island to finish packing. Local Maine women gave birth in small local hospitals or at home, but my mother's family was used to the medical school and its hospital, at Cornell in Ithaca, New York, so they wanted Mom to go to a bigger hospital in case something went wrong. They decided that it was too far to drive two hours to the nearest large hospital in Bangor with Mom in labor, so Mom went ahead to the hospital to languish for the last week of her pregnancy and wait for me to arrive. Sal was left with my grandparents.

I was born at last. After several days' rest, Mom came back to Hancock with me. Granny said that after Sal saw me, she turned to her and said, "Take her back, Granny. I don't want her."

Bob came to check that Mom and the new baby were okay, say good-bye to us and Sal, and catch a boat to Italy. He had to begin his scholarship year and find an apartment for the family.

When I was a month old, my grandparents drove Mom and Sal and me to New York City, where we caught a boat and sailed to Italy. Sal says that Mom's milk gave out halfway across the ocean. Maybe she was under some kind of stress. A kind steward found some goat's milk, so I was saved.

Since then, I've wondered, where did he find that goat's milk? I don't think they had powdered milk in the 1940s. I have read that in the old days when sailing ships were gone for months at sea, they used to keep a goat on board for the officers' coffee and tea. Maybe even in the 1940s, there was a nanny goat on the steamship to provide fresh milk. Anyway, I am grateful.

Still, I wonder if Sal was traumatized by being left by her father for a month, and by her mother for a couple of weeks while I was born, and then traumatized some more when she was jerked off to a foreign country. She got scarlet fever while we were in Rome, so it must have been a rough time for her.

Mom read to us before we went to bed, but Granny told us stories. Many of her stories involved fairies. Granny said that the fairies were usually good to you if you were good to them, and she said that many people in Ireland used to put out a bowl of milk at night as a gift for them. But sometimes the fairies were mischievous. People took care not to offend them, so they called them the Good Folk, even if they sometimes weren't.

But Granny's fairy stories usually told more about the morality of humans than the morality of fairies. She told about a little girl who was mean-tempered and would not do anything her mother told her. The fairies stole her away and made her work hard, sweeping, cooking, washing dishes, and doing laundry. She tried to defy the fairies as she had defied her long-suffering mother, but the fairies pinched her, and she learned better. After a year, the fairies took her home again, and she discovered she had only been gone a single day. But she had learned to appreciate her mother and home. Ever after that, she was a kindly and hardworking girl and never again gave her mother any trouble.

Granny wrote down some of the stories she collected. One of these was *Journey Cake, Ho!* about a poor boy whose parents could not afford to support him, so they sent him off into the world to seek his fortune with just their blessings and a journey cake. The journey cake jumped out of his sack and led him on a wild adventure. Bob did the illustrations for this book.

Granny told a story about the Feast of St. Stephen, the day after Christmas. A poor man heard a knock on his door and opened it to a ragged stranger. He invited the stranger into his home to share his meager supper, and after supper, gave him a place to sleep. The poor man awoke in the morning to find the stranger vanished and a bag of gold on the table. Granny sang:

Harken ye all 'tis the feast of St. Stephen
Mark that ye keep it this holy even
Open the door and greet ye the stranger

Ye mind that the wee Lord had naught but a manger.

Mhvire as truagh.

From *This Way to Christmas* copyright expired

When I was about seven, I stayed at my grandparent's house without Sal. Before bed, Granny told me a story about the fairies. I enjoyed it, as I always had, but the next morning I asked her, "But Granny, are fairies real?" The look my grandmother gave me was such a combination of sorrow, pity, contempt, disappointment, resignation, and love, I never forgot it. She was one of the most capable, intelligent, and successful women I knew, then and later. Even at the age of seven I saw that she thought disbelief in the fairies was a sad degeneration of human thought and intelligence.

May Massee's house in Croton Falls, New York, where we spent our winters.

New York

We spent five months of the year in Maine and seven months at the home of May Massee, my father's editor, in Croton Falls, New York. May used the house as a weekend home in the summer, and she allowed us to use it for our winter home. But for me, New York State was never home as Maine was.

On the island, when the winds came more often out of the northwest, and the days turned cold and clear, we knew that fall was coming. Every Labor Day, my mother unpacked the textbooks she had collected from our school the previous spring, and set us to work at the playroom table. Bob usually lit the kerosene stove in the playroom when he got up, so the room was always warm. The fall sun fell on our backs. I particularly remember the year I was in third grade and Sal was in sixth. Sal and I were each studying our spelling lessons, and I looked over to see her words. One of them was *government*, and I learned how to spell that along with my own words.

When I thought I had my words learned, I took my spelling book out to the kitchen, where Mom was usually making jam or bread or making soup for lunch. While she worked, she glanced at my book on the kitchen table and made me spell out the words. I usually got them all right.

We also studied arithmetic and social studies. Most days, we studied for a couple of hours in the morning and then we were free for the rest of the day. From Labor Day until the middle of October, when we left for New York, we managed to cover the school lessons for our classes through January.

I always dreaded the transition to school, but once I got to New York, it was okay. I liked my friends and teachers, but school itself was boring. Those brief morning sessions in Maine had shown me the pleasure of learning on my own. And because we had learned so far ahead, the fall school months were an exercise in patience while the class went over the same work again. It continued to be slow going for the rest of the year.

When I was very young, my father had a studio about a mile away from our home in an outbuilding that belonged to our neighbors, Kate and Fritz. Usually, when Bob took me along to his studio, I went outside, where I could wander around the landscaped gardens. Kate and Fritz had a French gardener named Josef, who had made paths and steps and terraced levels with stone retaining walls. There were box hedges and rhododendron. He had dammed a small stream that ran past the house to make a pool and stocked it with goldfish. From the pool, the stream flowed down to the lake, where there was a small dock. My father said that he and his friend Marc Simont had lived in Kate and Fritz's house one winter, and Marc had built an igloo out on the lake.

Marc and Bee and their son, Doc, lived nearby in Cornwall, Connecticut. Marc could walk on his hands, and do a headstand with no hands. When he visited us in Maine, he ate raw sea urchins out of the shell. In Connecticut, the Simonts took us to see a tree house built for grown-ups, with glass windows and a kitchen table and chairs. Mom and Bee agreed that they would just as soon live on the ground. Think of carrying groceries up that ladder!

Marc sometimes talked about someone named Jim Thurber, who was a friend of his. Later, I learned that he illustrated some of Thurber's work.

Marc and Bob went to art school together and were roommates in New York City in the 1930s. Marc wrote and illustrated one of my all-time favorite books, *Polly's Oats*. He did drawings for *Sports Illustrated* for many years, and wrote and illustrated many other children's books.

Marc's son, Doc, called both his parents by their first names, Marc and Bee. I thought it was odd that he called his mother Bee, but thought it quite reasonable for him to call his father Marc, as I called my father Bob. My friends thought it was weird to call either parent by name. I guess it is what you are used to. I suspect that Bob and Marc discussed the matter, since they and Bee were the only parents I knew who were called by their first names, but Bob never explained why. I remember calling him Daddy once and seeing his irritation. I didn't do it again.

To return to Kate and Fritz, who owned my father's studio: They were doctors in New York City and came out to the country on weekends. After I grew up, I learned that Kate was lesbian and Fritz was gay. In those days, their marital arrangement gave them protection and respectability in their professional lives. The gardener, Josef, was Fritz's lover. Kate's special friend was an opera singer who often came down on weekends.

Several times a winter, Kate invited Mom and Sal and me over for tea. She made a ceremony of it, with a complete tea service: loose tea in a teapot and cups and saucers, a pitcher with milk, a sugar bowl with sugar cubes and silver tongs, and silver teaspoons. Sometimes she used a Japanese teapot and cups. She served fancy homemade cookies she had made herself, or fancy cookies she had bought in a shop in New York. The tea was delicious and tasted like what I now know to be Lapsang souchong. Kate said that she had her own blend made in the city. Kate talked like William F. Buckley, the only person I ever met who did.

When I was about six, Bob moved his studio back to our house. We were now in school, and probably not such a threat to his concentration. This studio was better than the one at Kate and Fritz's, but still grim compared to the one in Maine. It was just off the living room in the unheated part of the house, and had little light. When it was cold, Bob worked in his coat.

As I mentioned, our house belonged to my father's editor, May Massee. She used to visit us for a weekend every spring. By the time I knew her, she must have been in her seventies. She was thin and always wore a dress. She had very blue eyes and creamy white hair, which she wore in a bun. She seemed like a gentle, sweet woman, but she must have had some steel in her to become the top children's editor in the country. She had the shakes, which was apparently a benign genetic trouble, but it was suspenseful watching her bring a cup of coffee to her mouth.

My father also became friends with a man named Mort. Mort had the idea of filming the pictures in children's books, panning across the pages to simulate movement. In the film, someone read the story aloud, while music played. Mort said he didn't have any artistic talent, but he thought his films could bring books alive for kids who otherwise might never become interested in reading. Mort made movies of most of Bob's books, along with many of the children's books of the last fifty years. Mort is Morton Schindel, founder of Weston Woods Studios, which sells films to libraries and schools. He is an artist of a different kind.

My parents also knew Anne Carroll Moore. I knew that she was important in the world of children's books, but never knew precisely what she did. Now I discover that she was the Supervisor of Children's Works in the New York Public Library for thirty-five years, and was instrumental in developing policies for how libraries should treat children. Andrew Carnegie had funded many public libraries all over the country, but until the 1890s, children were not allowed in the libraries at all. Under Anne Carroll Moore, children were not only allowed to check books out, but were given a special room where they could read or come to hear people tell stories during story hours. My grandmother got her start telling stories to New York City children in the library system set up by Miss Moore.

Miss Moore ate caraway seeds for indigestion, and Sal called her Anne Caraway. Anne Caraway was especially fond of Sally and gave her a crocheted donkey, who was dear to her for many years.

I never got a donkey, but I had another treat. When I was about nine, Annis Duff, who had succeeded May as Bob's editor at Viking, sent *Pippi Longstocking* to me for Christmas. I fell in love with Pippi, and my parents told Annis how much I liked the book. A couple of years later, when Astrid Lindgren came to the United States, Annis took Mrs. Lindgren and my parents and me out to dinner at an Italian restaurant. I don't remember much about the dinner except that I liked Mrs. Lindgren. The restaurant was a long way from our house, and the drive home was long and dark. I fell asleep on Mrs. Lindgren's shoulder.

The Shaws were the caretakers for May's house, and they were both deaf. Shaw carried a notepad with him to talk with my father. I was embarrassed around Shaw, because his voice sounded strange, but my father taught me to respect him. Bob reminded me that his grandparents, Sal's and my great-grandparents, were both deaf from scarlet fever. He explained that they, like Shaw, carried notepads where they

wrote what they needed to say, although they usually communicated to each other just fine without notes. The Shaws used sign language with each other.

For Thanksgiving, Mom made turkey with wonderful stuffing and all the fixings. Sometimes she varied the stuffing, making it with chestnuts or oysters or wild rice. I tried to discourage any departures from regular bread stuffing.

My parents had been married on Thanksgiving, so they celebrated Thanksgiving as their anniversary. Mom often invited people who might be lonely to our Thanksgiving dinner. She might have invited this odd fellow as well.

After we ate, we usually walked off our dinner on the woods road on land that belonged to our neighbor Tamara. Sometimes there were lots of hoofprints on the trail, and we knew that the local hunt club, the Golden Bridge Hounds, had recently passed that way. Once I saw the hunt in the distance crossing Tompkins's Farm: beautiful horses and riders with red coats against the green of the cow pastures.

When we were old enough to be allowed to walk on the tar road by ourselves, Sal and I used to visit Tamara's place. She was an old lady who was usually away in New York City, but we had permission to visit her ponds, which were stocked with goldfish. In spring, we spent hours there catching and releasing pollywogs.

One Christmas, Tamara's brother came to visit her from Paris. They had a party for the neighborhood children, because Tamara said her brother didn't know any children and missed them. The brother dressed up as St. Nicholas and I sat on his knee. We were a little old for this, but we all played along so that Tamara's brother would have a good time. Mom said that St. Nicholas's real name was Mr. Kerensky and that he had been the leader of Russia before the Communists came to power.

When we were in New York, my parents sent us to Sunday school at the Methodist Church. From my parents' conversation I learned that they thought it important that we be exposed to religion. Bob didn't go to church, but Mom liked to go on Christmas and Easter.

When I was in second grade, my Sunday school class practiced a pageant for Christmas. I had a good part and was looking forward to it. On the week before we were to perform, my mother told me that our family was going into New York City to see The Nutcracker Ballet on the day of the Sunday school pageant. I said that I was supposed to be in our pageant, and I didn't want to go to New York. I had a rare fight with my mother. Mom said she would talk to my Sunday school teacher, and she did. I enjoyed The Nutcracker, but I was still resentful that my plans and the Sunday school's plans were unimportant to my parents. On the other hand, I admitted to myself that if my parents had not put their plans ahead of school plans, we never would have been able to go to Maine and skip over two months of school every year.

Before Christmas each year, Mom and Sal and I went down to the edge of the big swamp behind our house to collect ground pine for Christmas greens. My father made wreath rings out of old metal coat hangers, and peeled the cover off old lamp chords to retrieve the soft copper wire for winding the greens. In the living room, Sal and I made bunches of greens, which Mom wound onto the rings. Afterward we had tea. Later, my father hung the wreaths on our front and back doors.

One year, my father carved linoleum blocks to make prints for our Christmas cards. The print on the front of the card was of Sal and me going up the stairs on the island to bed, dressed in the new bathrobes my grandmother had made for us, carrying our candles to light the way. NOEL.

We watched while Bob printed the cards, and the next day we helped him fold them carefully, while Mom wrote greetings and letters to all their friends. Then, while she consulted her address book and addressed envelopes, Sal licked the stamps and put them on the envelopes and I licked the envelopes. The stamps only cost three cents apiece, so people could afford to send cards to almost all their acquaintances. It was a whole afternoon's job for the three of us. Then we had tea.

In school, we learned how to make paper chains to hang on the Christmas tree. My father decided he could improve on those chains. He cut some tin into tiny two-and-a-half-inch-long strips. Sal and I bent

these little strips into rings and linked them into a chain. Meanwhile, Bob made little one-inch-tall ornaments out of tin: masks, a boot, a gingerbread man, a goat head, a deer head, a lobster, a crab, a starfish, a fish, a bird, a sailboat, a tree, a daisy. The ornaments had tabs so they could be linked into the chain every couple of feet. We must have made thirty feet of chain, which we used for years on the Christmas tree instead of tinsel.

A couple of times each winter we went into New York City. Kate and Fritz had season tickets to the Metropolitan Opera, and sometimes they invited my family to use them. As I said, we went to The Nutcracker. I first heard Hendel's *Messiah* at the Met. We also went to The Museum of Natural History to see the dinosaurs. At the Metropolitan Museum, there were glass cases showing full suits of medieval armor. I was alarmed that by the time I was in fourth or fifth grade, I was already too large to fit in those suits.

We also went to the Central Park Zoo.

One day, when I was about six years old, we didn't leave until closing time. In a large rush of people, I got separated from my family. I started crying and a kind man took me with him through the crowd. Sure enough, by the front gate, we found my parents looking worried.

When I was seven, my parents left Sal and me with the Mortensens across the road, and went to Mexico. My father had been to Mexico before he married my mother, and now he and Mom went together. I don't remember missing them much. I do remember staying home sick from school one day. I was dozing in bed, when there was a crash, and a pheasant flew through the window. I screamed and crawled under the bed. Mrs. Mortensen charged in, took me into another room, and shut the door on the pheasant. I think the pheasant died, but my memory fails. Mr. Mortensen replaced the glass, and next evening, we were back in our room.

After a couple of months, my parents came home from Mexico, and we left on our yearly trip to Maine.

Journey to Maine with Bob

When I was eight, around 1956, my father bought what he called an old jalopy, a grey Dodge coup. My parents decided that year that Bob and I would go ahead to Maine in the jalopy, and Mom and Sal would follow a few days later with the family station wagon.

Bob and I left after lunch. Before we left the driveway, my father gave me a lesson in map reading, showing me the blue and red roads, the circles for towns and cities, the numbers showing the miles between points, the route numbers, and the distance scale at the bottom of the map. The map kept me amused as I learned how to direct my father onto the correct route. In the beginning, he knew the way, but as the trip went on, I was really able to help with directions. Occasionally, when I couldn't understand the map, my father had to pull over to look at it himself. There were no Interstates.

Later, we arrived at Mystic Museum in Connecticut, where we saw the handsome and romantic whaling ships. But down below, I was appalled by the small bunks for the crew. Were the men that small, or were they crammed in like sardines? I remembered the tiny suits of armor at the Metropolitan Museum in New York. In the old days, people must have been smaller.

Then we wandered through the town. We saw an old-fashioned printing press and an apothecary's shop, where my father bought some candy sticks: one each of peppermint, barley, lime, lemon, and cinnamon. Finally, we looked at the scrimshaw, and continued on our way.

It must have been a leisurely trip, since I remember the next morning we went to see Old Ironsides in Boston Harbor. Here the crew's bunks were even tinier.

I believe that we spent the second night somewhere on Route One in Maine. The next morning, we ate breakfast at Moody's Diner, which is a Maine landmark. I had pancakes and sausages. We also stopped at Perry's Nut House, where we saw a life-size wooden elephant and giraffe. We looked at ourselves in the funhouse mirrors and bought pistachio nuts.

We stopped to buy groceries, and then on the homestretch, we passed the peat moss farm, Mechanical Albert's, David's Folly, the earthworm farm, and the Grange. Finally we came to Weir Cove and the home of our caretakers, the Cliffords.

There my father conferred with Ferd about how the island and our boat had survived the winter. Mrs. Clifford caught us up on gossip of people my parents knew, but meant nothing to me. Then we went to our garage, where we parked the car and transferred our luggage and groceries down the path and dock and runway to our powerboat, which Ferd had tied to the Cliffords's dock.

My father started the engine, and we steamed across the bay to the island. Even at that young age, I felt I was coming home.

My father slowed the boat, approached the float at an angle, and reduced our speed to a glide. At the last second, he put the engine into reverse, gave her some gas and the wheel a spin, and the boat, on a collision course with the float, backed off just as nice as you please, and we came to a stop in perfect parallel to the float. I had the bow line in my hand, and stepped onto the float with panache. Then I went to the head of the float to wait for Bob. He picked up the stern and spring lines lying on the float, and made a turn around the stern cleat of the powerboat. I tied up the bow with the double half hitch I had down pat. We were home.

We transferred our luggage off the boat, onto the float, and up the runway to the pier. My father loaded our stuff onto the waiting red wheelbarrow, and I carried what I could.

We had to make several trips. We dropped Bob's easel, his portfolio with his big canvases and sketch pads, and the suitcase for his paints off at the studio in the boathouse. We continued up to the house with our groceries and luggage. Then we went to the pump house, where my father started the pump to give us water pressure, and made sure that the generator would start. Ferd said he had been able to start it, but it had been temperamental (he always said that), so when it started, we were relieved. We were always relieved. I took the wheelbarrow to the woodshed behind the pump house, and filled it with wood the Cliffords had cut and split. I made a couple of trips to the house, one with short wood for the stove in the kitchen, and one with longer wood for the fireplace in the living room.

Bob lit a fire in the kitchen stove. It was cold and damp, so we closed off the doors to the rest of the house until the kitchen warmed up. Bob went into the living room to light the temperamental floor furnace. I took my suitcase upstairs. Sal and I had been taking turns making our parents' beds along with our own for the past year, so I took some sheets from the linen closet and made the beds. I brought towels

and washcloths to the bathroom. Bob turned on the gas tank and lit the pilot lights for the refrigerator, hot water heater, and stove. He turned on the generator.

It had gotten dark, but with the generator running, we had lights. We met in the kitchen, which was now toasty warm. My father had unpacked the groceries. Now he showed me how he fried hot dogs and heated up the buns under the broiler. B&M baked beans simmered in a saucepan. Bob broke up some iceberg lettuce for salad and put some orange "French" dressing on it. The hot dogs and toasted buns and baked beans were excellent. The French dressing was pretty terrible and made me miss my mother's salads. It was my first experience of preferring Better Food. I can't remember if we had dessert. Then Bob washed the dishes while I dried and put them away.

In the morning after breakfast and washing the dishes, my father asked,

"Will you be all right by yourself?" and I said I would.

"Maybe you can sweep the floor?" and I said I would.

He took off for the studio. I swept the kitchen floor and then went into the playroom, where Sal's and my books were kept. We had a pretty good library, several long shelves. Every year at Christmas, my father's editor, May, sent Sal and me each five or six children's books that Viking Press had published that year. My parents also gave us books. The summer before, when my grandparents sold their home in Hancock, my grandmother gave us most of her books of folk tales and fairy tales and books on Norse and Greek mythology.

So, I went and looked over the books. I read some of my old favorite picture books: maybe *Polly's Oats*, *The Story of Ferdinand*, *Andy and the Lion*, and *Journey Cake, Ho!* Then I settled with one of the longer books. *Toro of the Little People*? *The Princess and the Goblin*? Or maybe my all-time favorite: *Jungle Book*, with Mowgli and Bagheera and the Wolf Pack family.

When it warmed up outside later in the morning, I explored the island. I went out to the point, around the island on the beach, and visited the gazey beau. That's what the Clifford's called our gazebo, and our family adopted the pronunciation from them. Later I went down on the beach and turned over rocks to find the small green crabs underneath.

My father and I spent a couple of days together with just the two of us. Bob showed me how to cook scrambled and fried eggs and bacon and hamburgers. He cooked spaghetti, and said that when he and Marc were in art school in New York, they used to eat a pound of spaghetti apiece.

Just when I began to miss my mother and my sister, they arrived, and we resumed our normal course of family life.

Mexico, First Year

When I was nine, a couple of years after my parents' trip to Mexico, my father came home from New York City with a Berlitz record that taught basic Spanish. My parents had decided that Sal and I were old enough to go to Mexico, too. I thought this was a great idea until I learned that we each had to have three typhoid shots, a tetanus shot, and a smallpox shot.

We had all had polio shots several years before. My second polio shot had made me sick, and I had harbored doubts about shots ever since. I was a good kid though, so I gritted my teeth and suffered the shots. The typhoid shots made my arm stiff for weeks. On the up side, I listened to the Berlitz record every day when I came home from school, and again with the rest of the family in the evening before dinner. I learned how to say *hello, good-bye, good morning, good afternoon, good evening, how are you, I am fine, please, thank you, you're welcome, what time is it, it is six o'clock, where is the hotel, to the left, to the right, I would like, I don't like, come, go, here, there, yes, no, one, two, three* (up to *100*). It is surprising how far these few words and phrases can take you.

We packed our new pink station wagon, which had replaced the old blue station wagon with wooden sides. We drove for two weeks, all the way down to Taxco, Mexico.

My parents had friends in Maine, John and Claire Evans, who owned a house in Taxco and rented it to us. Mom settled Sal in the *Escuela Secondaria* secondary school, and me in the *Escuela Borda* primary school. My school was named after the Spanish founder of the town, Jose de la Borda. I was glad to find that there was a Mexican-American girl from Detroit in my school, whose father had come to Taxco to work in the silver mine. Diana spoke pretty good Spanish, and was able to help me in my Spanish immersion.

In class, we had no textbooks. Once a week, the teacher gave us a ten-minute dictation on some aspect of Mexican history or government. The students wrote down the dictation, and then spent the week memorizing it, word for word. I had no idea what the teacher was saying. I could not write down what she was saying, let alone memorize it, although my friend Diana did it pretty well. I told my mother of my trouble, and she came and talked to my teacher, who gave me dispensation from the dictation.

Whenever the girls had free time, we were supposed to work on our embroidery. So, while the others memorized their dictation, I worked on my embroidery. The piece I worked on was not very attractive, but I learned to do a reasonable satin stitch, and in later years, did a couple of embroideries I liked. The Pineda twins worked together on a tablecloth whose beauty was sure to earn it a place of honor in the family linens.

At 10:30 we had recess, and many of us ran out to buy a taco from the taco lady. For just a peso, eight cents, she sold potato tacos with green salsa verde, the best tacos I ever ate. After recess, we had another short stretch in class, and then went home at noon for lunch.

The house we rented came with a cook, a maid, and a gardener. Our cook, Ophelia, made us lunch, and then I would go up to the little house, the *casita*, where Sal and I had our bedrooms, to read until three o'clock. After the siesta, I went back to school for another two hours until five.

The afternoon session began with penmanship. The teacher wrote a short maxim on the blackboard, which we copied into our notebooks. Then we wrote a page of the maxim in our best hand, and took it up to the teacher for grading. I did very well in penmanship, even though I usually had no idea what I was writing. *Gracias* and *hasta mañana* didn't get me very far in Spanish academics, though I got so I could talk pretty well with my friends.

After we got settled with our maxim, a man would come to the door of the classroom with a red wooden box. We were allowed to go up to him, five or six at a time, to buy *paleta* popsicles for twenty centavos, less than two cents apiece. The *paletas* were delicious: pineapple, watermelon, or lime, with natural flavor and lots of food coloring. It was the kind of street food I had been warned about, but because it was served in school, it didn't dawn on me at first that I shouldn't be eating it. Later, I figured I had survived so far, and continued to eat those *paletas*. All my friends did.

I only remember one of the maxims we wrote in our penmanship lessons. Usually, our class was extremely well mannered. Even with twice the students as in an American classroom, about fifty, we were much quieter. However, one day, we got noisy. The teacher called for order, and we quieted, but then we grew noisy again. She yelled for order and gave us an unusual dressing-down. Then she assigned us our penmanship maxim: "*Debo guardar el silencio.*" I must keep the silence. Our assignment was not just a single page. We had to take it home and write it five hundred times. It took hours. I will keep the silence. I will keep the silence. I will keep the silence. I will keep the silence.

Most days, we finished the afternoon with arithmetic. The teacher wrote three problems on the blackboard, and we worked on them until it was time to go home. Our homework was to complete the problems, which were graded first thing in the morning. In New York, I had learned multiplication and long division just before I left, but these were still very new skills to me. In Mexico, I was frightened to find that our first three problems looked something like this:

147409482	837408172	945821560
X 49065	X 29835	X 31597

I took these problems to my father, who showed me how to carry the 4 and so on, and after that it was just a matter of slogging through the problem. I rarely got all three problems right, but I learned to do lesser problems with ease.

The next day, we got comparable numbers in long division, nine digits divided by five. Again, my father showed me the way, and I slogged through them. I was pleased that in arithmetic, I was able to do as well as or better than most of the other kids.

In general, after being a top student in New York, I found this Mexican school a lesson in humility. We had a standardized test in the spring, and I got 1 or 2 out of 10 on all the subjects except arithmetic and penmanship, where I got 9 out of 10 and 10 out of 10.

In my Mexican school, we didn't have individual desks. I shared a bench-desk combination called a *banco* with two or three other girls. The boys were seated in *bancos* in the back of the room, separated

from the girls. I was in the fourth grade on the right side of the room. The fifth grade was on the left side, which was also divided with the girls in the front and the boys in the back. There were about fifty students in a room about two-thirds the size of my American classroom, which held about twenty-two students. There were two teachers, one for each grade.

I made friends with my seatmates. I remember Diana from the States; the Pineda twins, whose father was one of the top silversmiths in town; little Cristina; and Maria Elena. I had friends to talk with in school and walk home from school with. A lady near the school sold green mangos on a table in front of her door. She sliced the mangos on either side of the pit, and sprinkled them with a mixture of chile and salt. It is a great combination.

In the morning, we stopped at a candy store right outside the school, and bought centavo candy. Our teacher didn't mind us eating candy, as long as we didn't disturb the class. My parents knew the prices of the Cokes and popsicles and ice cream at the expensive kiosks in the main square *zócalo*. Based on those prices, they gave me a five-peso (forty-cent) allowance every week. They didn't know the cheap prices of the little candy *tiendas* in the back streets.

My five-peso allowance was enough to buy me more candy than was good for me.

Sometimes on the way home from school, I stopped at the American Library. It was a small room, and had only two shelves of books for children, which were almost completely occupied by complete sets of the Dr. Doolittle and Oz books. There were about twelve Dr. Doolittle books and thirty-five Oz books. I have probably read more Dr. Doolittle and Oz than anybody. There was nothing else to read.

The house we rented was called the Casa Scott. Before John and Claire Evans bought it, it had belonged to an unmarried American woman, Natalie Scott, who, according to the story I heard, came over the mountains to Taxco in the 1920s on the back of a burro. According to her biographer, John W. Scott, this is not true: she came in a dilapidated station wagon.

Natalie Scott was an adventurer, nurse, and patron of the arts who died a few years before we arrived. She worked in the Red Cross during both World Wars. She knew and supported the writers and artists in her native New Orleans, and knew Oliver La Farge, William Faulkner, and William Spratling. She

continued to support the arts when she came to Taxco, and she founded an orphanage there. We visited Natalie Scott's grave on *Dia de los Santos*.

Claire came to visit us for a couple of days. She spoke of a poet she had known in Mexico many years before. He was an unhappy soul, poor boy (of course, he drank like a fish), and she had to say she wasn't surprised when he killed himself. Jumped overboard. Such a shame; he was so talented. Years later, I met Claire's granddaughter-in-law. She said that when she heard Claire's tale of the poet in Mexico—*Hart Crane*—she was so impressed she wrote her master's degree thesis on him and "The Brooklyn Bridge."

My mother said that John Evans was the son of Mabel Dodge Luhan, who was a famous patron of the arts in New York City, Europe and Taos, New Mexico. She married three husbands and was very wealthy. Her fourth husband was Tony Luhan, a Taos Pueblo Indian. She tired of him, as she did all her husbands, but, according to the story I was told, there was some law that she couldn't divorce an Indian, so they stayed married though separated. I later learned that Mabel Dodge was a friend, lover, and patron of D. H. Lawrence in Taos.

Her son, John Evans, had spent much time in New Mexico. John knew that I liked horses, so later, after we returned from Mexico, he gave me a saddle blanket that had belonged to Tony Luhan. It was pretty old, made when weavers were changing from natural to synthetic dyes. The blanket was made with all natural red dye, which had faded to a soft pinky orange, except for the last few rows, which were synthetic and stayed bright red.

The Platts were our neighbors next door to the Casa Scott. Dr. Platt liked to go down to the main square *zócalo* in the late morning and watch the people go by. The people going by liked to watch him, too. He was the picture of an old cowboy, about seventy-five years old, dressed in faded blue jeans, blue plaid shirt, red neck bandana, white Stetson hat, and cowboy boots. He said that one day an American lady stopped and asked him, "Sir, what part of the West are you from?" And he answered, "Western Connecticut, Ma'am."

Dr. Platt was a good amateur artist who specialized in etching. My father took lessons from him. Dr. Platt also owned a Pinto horse, which he rode once a week, and a retired white racehorse, which couldn't be ridden but needed a home.

He said he had been a doctor in the cavalry in the Spanish-American War in the Philippines. He told me that once his company rode forty miles to somewhere, and then rode forty miles back again, eighty miles in one day. He said that the McClellan saddles they used were terrible, and that he rubbed a hole in his leg that day.

Mrs. Platt had arthritis and only rarely went down the hill to the *zócalo*. Sal and I went over to visit her. We played Chinese checkers and ate cookies and drank Coke. No one drank milk in Mexico, because it wasn't pasteurized.

Actually, Sal and I did drink milk for a while. My mother worried about our calcium intake, so she bought some horrible Mexican powdered milk, and fed it to us morning and evening. I thought American powdered milk was pretty awful, but Mexican powdered milk was really, truly awful. Mom said it was because it was made with the fat in it. This regimen went on for a month until I drank my glass and promptly threw it up on the floor. After that, we escaped the milk.

The Platts told us that the year before, late one evening, the mayor of Taxco and the president of the local Coca Cola bottling company had a duel with guns over a woman. It happened that just as they shot, the Platt's maid stepped between them, and one of them shot her in the arm. The duelists paid for her medical bills and she recovered satisfactorily.

Mom sent me down every couple of weeks to the *zócalo* to get my shoes shined. I hated being served in this way, because the boys working on my feet were about my age. At home, we shined our own shoes, but here, we had other people do it. These boys needed the money they made from people like me.

There were kiosks in the square, and a juke box. I loved the Mexican love songs and American pop songs. "He's Got the Whole World in his Hands." "Itsy Bitsy Teenie Weenie Yellow Polka Dot Bikini." "Love Me Tender." "Yellow Rose of Texas." "Que Sera Sera."

Santa Prisca Cathedral was on the square, so huge its presence permeated the whole town. I learned that Santa Prisca was an example of baroque architecture. Every part of the front of the church was carved with statues, twisted columns, cherubs, angels, and saints.

.Every hour, boys rang the bells in the towers, great solemn, beautiful sounds that echoed over the town. There were other churches with bells in town, and when one church began, the others chimed in. The other bells were not so deep and mellow as the ones at Santa Prisca, but it was thrilling to hear the whole town pealing with bells. On fiesta days, bells might toll for minutes at a time, any time.

I got sick with *la turista* dysentery once that year. While I was sick, I dreamed that Mom and Sal and I stood on the slope in front of our house, looking down the hill to Santa Prisca in the *zócalo*. We were waiting for the bells to fall out of the tower. This dream seemed real to me, and fraught with ominous portent. When I awoke, I asked Mom if the bells had fallen out of the cathedral yet.

My grandparents came to Taxco to visit us. Granddad used to come down to the *zócalo* and visit on one of the benches with Dr. Platt, two old doctors together. Then, when I came into the *zócalo* from school, my grandfather and I would walk up the hill to our house. We talked of all sorts of things.

He liked puzzles and jokes. "What is the shortest poem in the world?" he asked. He would answer, "The title is 'Fleas: Adam had 'em." He also told me the classic palindrome written about Napoleon: "Able was I e're I saw Elba.." This made little sense to me at the time.

We stopped to rest on a stone bench halfway up the hill. He pulled out a paper and pen and wrote the following.

Wood
John
Mass.

He said a letter found in the post office had this as its address. How was the post office to deliver it? I had no idea, so he wrote:

John Underwood
Andover
Mass.

Granddad and I were especially close, and Granny and Sal were especially close. Granny sympathized with Sally's temper and the trouble it caused her with our parents. Granny said that she had a temper when she was a girl and it got her into trouble with her parents, too. She admired Sally because she said Sal had Gumption. Gumption, we understood, meant courage and determination and get-up-and-go. Sal had it, and still does.

Soon after my grandparents left, Sal and I moved back to the little house *casita,* where they had stayed. My father was a little worried before we moved in, because he thought that the bed seemed mussed in Sal's room. He wondered if our maid, Ravena, who was young and pretty, was meeting her boyfriend there.

On the fiesta *of Dia de los Jarros,* Day of the Pitchers (and all kinds of pottery), my parents gave me a beautiful pottery Pinto horse with a tail that was a whistle. I joked that if there was any trouble in the *casita,* I could whistle for help.

That night, I took a break from the Oz books to read my *Girl Scout Handbook.* I wanted to see if I could earn any badges while I was in Mexico, but it seemed I couldn't. I turned out the light and Sal turned out hers. I was nearly asleep when Sal said, "Jane?" I was about to answer when she said, "Mom?" I was waking up fast. "Bob?" I fumbled for the light. There was a scuffle, and then Sal was yelling at the top of her lungs, "Bob! Bob! Bob!" I finally got the light on, and ran into Sal's room in time to see a figure escape out the door. I ran back and got my Pinto horse and whistled hard, which was really unnecessary after Sal's yell. A minute later, Bob charged in the door with a machete, but the intruder was gone.

Sal and I went down to the main house to sleep. My parents moved up to the *casita,* and those arrangements remained for the rest of our stay. Dr. Platt lent my father a .45 pistol, with a warning about what he said was Mexican law. He said that we couldn't leave the gun in the house if we weren't home. Every time we went anywhere, the gun had to come along in the bottom of the picnic hamper.

In May, our family packed the station wagon and we made the trip back to Maine.

Trouble in Paradise

Maybe because I loved the island and the bay so much, I worried from a young age about environmental problems, even though I—and most people—had never heard the word *environment*.

A lot of sea creatures disappeared during my childhood. My parents said that until Sally was four years old, they all rowed out in the big rowboat to the mooring in our cove. There they fished and caught flounder for dinner. Sal once even caught a large lobster by its claw, which they took home and put in the pot. I never once caught a flounder and certainly never a lobster. We went clam digging several times each summer. Every year, the clams became scarcer. By the time I was eight or nine, we got maybe one mess of clams for clam spaghetti every year.

Sal and I went down to the dock to fish for big green crabs. We could always find a couple of clams to bait our lines. The crabs grabbed onto the bait with their claws and never let go as we pulled them up through the dim, clear green water and onto the dock. We caught a bucket full and then threw them back, because Mom said they were too small to pick out.

Then one year, the green crabs were all gone. In their place were lots of starfish, some about a foot across, and large piles of sea urchins clumped up together. I worried about the changes in the water. No flounder, no clams, no green crabs—too many starfish and sea urchins.

People said that until recently, you could catch halibut, haddock, and cod off Eagle Island, which was about two islands away from us to the south. You couldn't anymore. When I was about eight, our neighbor Jake took us out on his ketch sailboat, the *Calista*, to go deep sea fishing. We went much further down the bay than Eagle Island, but we still didn't catch anything except dogfish, which aren't good eating and look like miniature sharks. I never caught a cod or haddock or halibut.

Ferd said that bluefish used to come up Horseshoe Creek on Cape Rosier. In the 1930s, some guy dynamited the creek so he could catch a lot of fish. I guess he killed them all, because Ferd said that the bluefish never returned after that.

An ugly green seaweed appeared on our front beach at low tide. I heard my parents talking about the paper mills and their pollution of the river and the bay. There was also a chicken slaughter house across the bay from us in Belfast Harbor. The chicken heads and guts were thrown overboard into the bay. People said that a great white shark lived near the factory and ate the chicken waste. I wondered if the paper mills or the chicken factory were causing the ugly green seaweed.

Years later, I learned that enteromorpha seaweed, also known as green slime, is an emerging nuisance seaweed all over the world. It grows where there are too many nutrients in the water.

Fertilizer runoff is one cause of high nutrient levels in water. Sewage discharge is another. My parents had put in a septic system on the island several years before. It was probably not properly sited, and the sewage must have leaked and caused the green slime on our beach. Years later, a backhoe came to work on the island. It backed off the scow, lumbered up the beach onto the lawn, and fell into the old septic system. My parents got a new septic system built to current standards, and the green slime disappeared.

When I was about six, I heard my mother speak to a friend about an article she had read about population growth. The article claimed that if population growth continued at current levels, by the year such-and-such, people would only have one square yard apiece to stand on. I had a nightmare that night about being on my square yard, but separated by a couple of squares from my family. The people in between us might not let me get to my mother and father. I have been a population watcher ever since.

In our *Weekly Reader* at school, an article warned about the erosion of soil in the Midwest. When white people came to the plains, the fertile topsoil was about a foot deep. In one hundred years of farming, half the topsoil had eroded, and was now only six inches deep.

I worried about the effect of human beings on our world.

As I was learning to worry about the greater world, I also began to worry about our personal world. Edee's mother, Mary, became a serious alcoholic. My parents had known this for some time, but for me it was a shock to come to their house one afternoon to find her passed out on the front step. My parents called her husband, Bill, whose job was now in Atlanta. He came up for a weekend and hired Tina, a young woman from Little Deer Isle, to take care of his wife and daughter. He went back to his job, and my mother sent me over to keep Edee company.

We had a surprisingly good summer, with a sad undercurrent. Edee had been living with this secret for years, and she said it was a relief to have her mother's drinking out in the open. Her mother stayed in her darkened bedroom most of the time, and we saw her rarely.

Edee's father rented a horse for us as consolation. We had a fine time removing the junk from a stall in their ancient barn and hammering a few boards into place for the new horse. When the horse came (her name was Flicka), we rode her up to Walter Douglas's store for penny candy. Sometimes we meandered through the woods, down to the shore, and around the field.

The owners had warned us that the horse sometimes bit people when she didn't want to come in from the pasture. Finally in late summer, she bit me. She hardly broke the skin, but my hand was sore for a couple of days. The horse went back to her home.

A couple of times over the summer, we spent the night at my home on the island. The second time, I wanted to stay home with my family for a rest. My mother said it was my duty to keep Edee company, so we went back to her house. At the end of summer, Edee and her mother rejoined her father in Atlanta.

Mexico, Second Year

In October, instead of going to New York, we returned to Taxco. That year, the Casa Scott was already rented to other people, so we stayed at another place in the center of town overlooking the main square *zócalo*. Our apartment was part of a palace that had been built in the 1700s by Jose de la Borda, the Spanish town father who made a fortune from Taxco's silver mines. He made a fortune, but he also gave to charity, and he built the cathedral of Santa Prisca, a magnificent building in the hinterlands of Mexico. He built his palace near the cathedral on the slope next to the *zócalo*, four stories tall on one side, two on the other.

When we lived in the Casa Borda, priests occupied the top floor of one end of the palace. Our apartment was on the top floor of the other half of the building. We had two bedrooms, a living room, a dining room, a kitchen, a bath, and a large, flat roof with a glorious 360-degree view of the *zócalo*, Santa Prisca, and the whole town. I have looked on the Internet, and this building is now the Centro de Cultura de Taxco.

Our apartment was built around a courtyard, but we were on the second floor. The bottom floor was three floors down in the basement, where there was a silver workshop. There the silversmiths braised and forged and pounded and cast and filed the silver and other metals and gems. It looked like a dim hell, with fiery forges and welding sparks, Bunsen burners, sharpeners, drills, and saws. Metallic and chemical smells rose to our balcony. On the first floor was the silver shop, which sold the silver worked in the basement. There was also a dress shop, where pretty young women worked, sewing and embroidering. When the guys in the basement saw them walk by, they whistled enthusiastically. We acquired a parrot named Perrico, who learned to whistle from the silversmiths, so the senoritas received admiration from below and above.

Earlier that year, we had adopted our dog Finny, and we brought him with us to Taxco. It was my privilege to walk him every morning before school. The wild dogs in Taxco were no match for him, although he wasn't aggressive, but there was always the worry that several dogs would pack up and bother him. None ever did.

Finny and I made friends with the maître d' of a local hotel.

In the spring, the priests held the Blessing of the Animals in front of the cathedral. People came with their dogs, cats, burros, horses, goats, pigs, parrots, parakeets, chickens, and turkeys to be blessed. We brought Finny and he was blessed, too.

My father set up his studio in the gallery of our apartment overlooking the silver workshop in the basement. He had just finished *Time of Wonder* and was looking for new ideas. He did a lot of sketching and painting that year.

During his previous visits, Bob had made friends with a boy named Angel. Angel and his little brother, Jesus, went to the *ExConvento* public school across town from the private *Escuela Borda*. Angel made money washing cars, running errands, and posing for my father. Bob said that Angel was an operator. Angel was about my age, but his experience and mine were so different, we said hi shyly and let it go at that. If he was an operator, he must have been driven to it. In Bob's sketches and painting, he looks sorrowful and worried.

Mom took guitar lessons and had a guitar made. Her teacher taught her some Mexican songs, which she taught to Sal and me.

I thought that this year I would be expected to take and memorize the dictation at school, but I knew I could not do it. Mom went to the teachers and, once again, they said I did not have to take the dictation.

Except for Diana, who had returned to the States, the same girls were at school this year. We were now in the fifth grade, on the left side of the same classroom. I became special friends with Maria Elena. We were pleased to discover that her house was directly below my family's new apartment, and that the balcony in our bathroom overlooked their terrace. We could call back and forth to make plans to meet. Maria Elena was sometimes called Elena.

I went over to her house often. Her mother was a pretty, thin, high-strung woman who spent much of her time with headaches in her darkened bedroom. Elena's older sister, Ana, who must have been about seventeen, did most of the cooking and cleaning. Elena's sister used to serve us carne, meat with tortillas, which was delicious. She also served the most impressive alphabet soup I ever ate. We could find the entire alphabet in a bowl of her soup.

Elena's father worked as an engineer in the mine. The Santa Cruz family had a television, and on Sunday afternoons Mr. Santa Cruz watched bullfights the way American men watch baseball and football.

Elena had two brothers, Pepe and Ramon. Ramon persuaded the rest of us to play bullfights. Someone would hold out a jacket like a matador's cape and shake it temptingly at another person, yelling, "Eh eh, Toro, toro!" Then the other person would paw the terrace with one foot, lower the upper body, and charge at the jacket, while the bullfighter executed a pass. This game was surprisingly satisfying for both parties, sort of like a dance for kids. We often had toros charging the jacket in sequence.

Hula hoops were popular that year in Mexico. They had been popular the year before in the United States, so I was good at hooping. Elena and I hooped. We and the boys also played with the soccer ball.

Maria Elena and I picked up some of each other's words. Even in English, I spoke of my *bolsa* (my pocketbook) or of my *cuaderno* (my notebook). And instead of Juanita, Elena began to call me Jane, or actually, Chen. She often heard me exclaim "Ow!" and "Ouch!" when I got hurt. One day her mother heard her say "Ouch!" and gave her a lecture that "Ouch!" was a terrible sound and unladylike. Elena was embarrassed, because I was right there. She said, "But Chen says it." Her mother replied that it was okay for an American, but not for her. She should say "Ai!"

A priest came to my school to teach the catechism. He had spent a few months in a religious seminary in Texas in his youth, and he remembered one maxim from that time: GOOD - GOD = O. He singled me

out, because he worried that I, as a Protestant, would go to hell. To him, being a Protestant was O. My friends became worried also. They asked me to come to Mass with them, and offered me a mantilla for my hair.

My grandparents had joined us in Mexico and were living in a basement apartment in still another part of the Borda palace. I told my grandmother about this uncomfortable religious pressure. I didn't think I was going to hell, but it was unnerving that my friends thought I might. Granny said that I was learning to meet different kinds of people. She said that the freedom I had to roam around Taxco and meet new people on my own was a precious thing.

She said she had a similar gift of freedom in New York City when she was my age. She had received a pair of roller skates for Christmas, and the skates allowed her to explore the city and meet different people. It was a wonderful time for her, but also filled with pain: She made friends with a girl who soon after died of tuberculosis. Freedom came with sorrow.

These friends of mine were sincere, she said, but they were Catholics and we were Protestants, and had our own tradition. When I grew up, I could make up my own mind about what to believe.

The Casa Borda apartment came with a full-time cook and maid, mother and daughter, and their cousin who came in twice a week to wash our clothes at the concrete washing stand on the roof. The apartment and the help of three women cost $100 a month.

That year, my parents were often gone for lunch. Mom had her guitar lessons and made friends with an American woman who was married to a Mexican. This Elena, as opposed to my friend Elena, was a born mother, and, in addition to a couple of kids of her own, had also adopted several children whose mothers could not care for them. While we were in Taxco that year, she rescued a tiny starving baby from death. Mom helped Elena as she spent a couple of months in close attendance on this baby, feeding her formula, conferring with the doctor, helping the infant recover from her severe dehydration and starvation. The baby lived. Elena's husband ran off with another woman.

Mom was especially fond of one old American lady she met at a party. Alice had what she called a "fallen womb". When the doctors could not help her, she asked her maid, Lupe, if a *curandero*, an Indian

doctor, could help her. The *curandero* came and made Alice stand on her head for half an hour a day. Lupe stood by, keeping Alice balanced, and within a month, her womb was healed.

Alice was living on a limited income, and as she got older, she worried whether it would keep up with inflation in her old (older) age, and take care of Lupe when she was gone. While we were in Taxco, a visiting American man met Alice and made her a proposition. He had seen and liked her house, and said that he would be glad to pay her for the house now. She could continue to live in it for her lifetime, and have the money too. He would benefit because he would pay the current market price before real estate prices went higher, and would have a house in Taxco waiting for him when he was ready to retire.

Alice took him up on the deal. Ten years later, my parents went back to Taxco and learned that Alice was alive and well, the American had died, and the house had reverted to Alice. Alice then entered into the same house-selling deal with a second American. Ten years after that, we heard on the grapevine that the second American had also died. Alice lived on.

My mother began to volunteer at the Taxco orphanage. I was glad she was doing that. Mexico was beautiful, and for us a delight, but the contrast between our good fortune and the lives of some local children was appalling. One day, when I was in the *zócalo*, a girl my age approached. She was wearing the brown-and-white-check uniform dress of the public *ExConvento* school. I wore the blue-and-white-check pinafore (yes, it was called a pinafore) of the private *Escuela Borda*. This girl struck up a conversation, asking about life *en los Estados Unidos*. She said her name was Roberta, and she asked if we had a television. That was the first question everyone asked. Maria Elena's family was ahead of most Mexicans because they had a TV. I said we did in *Nueva York*, but not in Maine. No TV? She was astonished. Did we have a *carro*? Yes, we had a *carro*. We talked several times.

One day, when I was in the *zócalo*, Roberta sat down beside me on the bench. Her dress had a small tear in the shoulder. She pointed about twenty feet away to a little girl lying half on her side, leaning on an elbow, like Christina in the Andrew Wyeth painting. "She is my sister," Roberta said. I was horrified. I had seen this little girl several times, dragging herself about the cobbled streets of town, over slimy mango pits, discarded banana peels and animal droppings, past loose pigs and burros and chickens. She had something wrong with her lower body, which was bent and crippled. The little girl sometimes

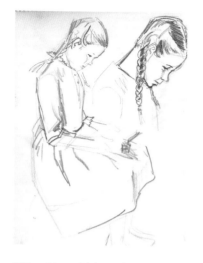

begged from the tourists, as did Roberta. Now Roberta asked me, "Do you have any extra dresses?" In those days, women and girls did not wear pants, ever. They were considered unladylike. We usually wore dresses and sometimes skirts. She wasn't asking for anything fancy; she needed clothes. I said, "Let me ask my mother."

I went home and told this story, and my mother recognized the girls from her work with Elena and the orphanage. Their mother was a notorious alcoholic in town, and the doctors were trying to get legal permission to take the girls away from her. The little girl could have been helped with an operation, but because the crippled child made good money begging from the tourists, the mother would not allow her to be treated.

Within a day or two, Mom and I went to a dress shop in still another part of the Borda building, and I got fitted for several new dresses, which got made in a week. Some of my old dresses and maybe some new ones went to Roberta. We were pretty much the same size.

My parents were part of the American-Mexican artist colony in Taxco. There were a lot of parties and a lot of drinking. Usually parties were in the evening, but sometimes, there were luncheons.

So, often at lunch, I ate in lonely splendor at the huge Spanish colonial dining table built to seat twelve. Sal was in school, my parents were doing their business about town, and Aurora's daughter was out doing the marketing. Aurora, our cook, waited on me. She and I became friendly during these quiet lunches. Sometimes in the afternoon, she sat down to rest, and put her hand to her chest. She said she had a bad heart. I worried about her walking in from the outskirts of town to work for us, more than a half mile each way. We had visited her home once. I wondered what her life with her daughter was like, with just a couple of tiny rooms, a single light bulb, and no plumbing. She said about the pain in her heart, "Ai, Juanita, don't worry; it's not your fault. You can't do anything about it. I will be fine."

The bath water in our bathroom was heated by a tiny woodstove, which was fueled with huge pine-cones brought in by burro from the countryside. The pinecones were stored in a corner of our gallery overlooking the silver workshop. One day, when Sal picked out cones from the pile to load the wood-stove, a tarantula dropped out. The shouting was all over by the time I got home from school.

On Sundays, Mom and Sal and I went horseback riding with a guide. Mom rode a big chestnut, while Sal and I and our guide rode small flea-bitten greys. We rode all around the country near Taxco, by quiet, tree-shaded streams in the lowlands; by an adobe brick factory on a hot, dry, high plateau; past poverty-stricken stick houses and corn fields in the hills. Sometimes we met people alone or in groups, afoot or on burros or horses, going about their business.

Once we took a picnic to a waterfall hidden in the mountains. It was more than a hundred feet tall, cool and lovely in the hot day. On the way home, my horse ran away with me. I lost the reins, but held on to the pommel and clung with my legs. Our guide overtook me and saved me before I fell off. Once or twice, Dr. Platt joined us on his beloved Pinto, but he was getting stiff and didn't ride much anymore.

My favorite ride was to the Posada de la Mision, an ancient Inn of the Mission, which our guide told us was built on the King's Highway, the Camino Real. He said that the Camino Real was built in colonial times and went from Acapulco on the west coast through Taxco and Mexico City to Veracruz on the east coast. The road was built to funnel the silver and gold from the mines of Mexico back to the coffers of the King of Spain. A small bit of the Camino was still cobbled outside the courtyard of the inn, but it turned to dirt fifty feet from the gate. On the wall forming one side of the courtyard was a jungle of wild philodendrons, those houseplants with huge heart-shaped, holey leaves. Trees shaded the courtyard, cooling us after our hot ride. I imagined caravans of burros, loaded with silver and gold, milling around within the enclosing walls, also enjoying the shade, while vaqueros and soldiers on horseback shouted and quirted.

We dismounted from our horses and went through another gated wall to the inn buildings. You could buy a delicious *limonada* at a bar there, and grown-up drinks. There was only one lonesome man tending the bar, and there never seemed to be any guests but us. I asked him how he made the delicious *limonadas*, and he told me that he made them with limes, honey, and fizzy water. I tried it when I got back to the States, and it made fine limeade.

We continued past the bar to a big rectangular swimming pool surrounded by a large flagstone apron. Beyond the flagstones were scrublands extending to the hills in the distance. The pool was fed by a full-size aqueduct coming in from the hills. Now that I have been to Spain I know that the Taxco aqueduct, with its handsome arches, was a direct descendant of the Roman aqueducts in Spain built two thousand years ago. The Taxco aqueduct ended at the inn. A staircase sluice brought in a constant supply of water to the pool, while the rest went to feed the inn buildings. We used to walk up the steps of the sluice to the aqueduct. The water was cold and crystal clear.

That first time on horseback, we didn't go swimming, but once we found the place, our family came back again and again to picnic by the lost swimming pool and buy drinks and *limonadas* from the lonely bartender.

As Christmas approached, my grandparents were excited because my Uncle David and Aunt Edith, their son and daughter-in-law, were expecting a baby any day. Granny, who loved Christmas, was hoping the baby would be born on Christmas Day. It wasn't. This was probably just as well, since I later learned that my Aunt Edith was Jewish. By Christmas, we knew that the baby, named Marie, had been born safely in December. My cousin Marie, who has changed her name to Dannie, teaches computer biology at Carnegie Mellon.

The market in Taxco sold everything: fruits and vegetables, chickens and turkeys, pork, beef, goat, and horse, dead or on the hoof. There were clay pots, saddles and bridles and quirts and whips, *riatas* (lariats),

cow hooves for making glue, chicken feet for making gelatin and soup, notebooks and pens and pencils, pots and pans, coffee beans, herbs, *rebozos*, blankets, cloth, sewing and embroidery thread, needles and pins, shoes, sandals, clothes. I got my *cuadernos* (exercise books) and pens for school in the market. We did not use pencils.

Late one afternoon, my friends and I came through the *zócalo* on the way home from school, chattering and laughing. I became aware of an American couple watching us. The man turned to his wife and said, "That girl looks just like a little girl I know in Cincinnati." I translated to my friends, and we all laughed. I knew then that if my family stayed in Taxco, I could become Mexican.

One night, when a fair had come to town, my father took me for a ride on the Ferris wheel. Maria Elena was supposed to come but couldn't at the last minute. As we were hovering in our seat in the air, waiting for the other seats to fill, Bob told me that some Americans in Taxco might not be what they seemed. The CIA sometimes recruited people to work for the American government against the Communists. He said that artists were good prospects to work for the CIA, because they moved around a lot, and were not tied down by a normal job.

I wondered if someone was trying to recruit him. Maybe he had been recruited, or maybe he knew someone who had been recruited. And why would the CIA or the Russians care about what went on in Taxco?

On the other hand, the Casa Trotsky was only a few streets from the Casa Borda. I had heard my parents say the reason it was called the Casa Trotsky was that Trotsky, a Communist who had fled from the Soviet Union, had owned and lived in that house for a while.

Just now I have looked up Leon Trotsky. He was a Communist intellectual in the Soviet Union who opposed Stalin, and had come to Mexico to escape being murdered. It sounds as if the Taxco house wasn't fortified enough, so he moved to another house, which still wasn't fortified enough. In 1940, he was murdered in his fortified home near Mexico City by a Stalinist agent.

Anyway, Trotsky had been friends with Diego Rivera, who was also a Communist and lived in Mexico City. Rivera had died two years before, in 1957. William Spratling, who lived outside of Taxco and was the

founder of the Taxco silver industry, was also friends with Diego Rivera. My parents had met Bill Spratling, although they were not close to him. Many in my parents' circle were friends with Spratling, and possibly Rivera and a few others may have been Communists as well. And one was probably a CIA agent.

The seats were filled, the Ferris wheel began to turn, and the moment passed.

Some days, I visited one of the many Taxco silver shops on the way home from school. One of the shops with the prettiest designs was right below our apartment, part of the Borda complex. There were mirrors with cut tin frames, brass and iron andirons, silver and brass candlesticks, lamp bases, Kleenex box covers, pill boxes, trays and dishes, serving spoons and butter knives, saltcellars and pepper mills. There were two-foot-square chess sets made of a brown hardwood inlaid with gold, with six-inch wooden chess pieces inlaid with gold. There were chess sets made of rose-colored wood inlaid with silver. There were rings and earrings, bracelets, necklaces, pins, tie clasps, tie tacks, cuff links, bolero ties, and belt buckles.

The manager of the shop made friends with me. He was Mexican and spoke good English. He invited me to sit at his work desk, where he showed me some precious and semiprecious stones and taught me their names. He was choosing stones to put in a piece of jewelry. After I visited a few times, he gave me a small box of rejected stones: unworked or broken onyx, lapis lazuli, opals, jade, topaz, turquoise, garnets, and bloodstone.

Just last month, I bought a book called *Silver Masters of Mexico*, by Penny C. Morrill, about the shop downstairs from our apartment in Taxco. It was the Taller Borda, owned by Hector Aguilar, one of the top silversmiths in Taxco. I realize now that my friend was Chatto Flores, Aguilar's son-in-law. Flores was the designer of some of the chess sets and jewelry I found so beautiful, and Aguilar was the designer of the others. I see that Hector Aguilar was our landlord, owner of the Borda Palace (we sublet from some Americans named Hall), and that he designed the chairs in our living room. There are photographs of them in Morrill's book. Bob drew Mom sitting in one of them, playing the guitar.

People came from all over to visit Taxco during the Holy Week of Easter. On Good Friday and on Holy Saturday, processions walked between the principal churches of town to hear Mass at each church.

Guadalupe, Veracruz, and Santa Prisca were the biggest churches, but there were a dozen others. The circuit among all the churches was said to be six kilometers. Every year, men who felt that they had sinned badly, or pious men who felt that they and the rest of us sinned all the time, walked the circuit of the churches carrying bundles of thorns tied to their backs and outstretched arms. They needed helpers to get the thorn bundles on and off.

When we were in the Casa Borda, the watchman and janitor for our building was a helper for one of the *penitentes*. The bundle of thorns the man was to carry stayed in our entryway for a couple of weeks before Easter. It was more than four feet long, a foot in diameter, and had thorns on it like rose thorns, about half to three quarters of an inch long. It must have weighed fifty pounds. On Good Friday, the bundle was gone.

On Holy Saturday, we sat on our balcony in the comfortable shade, drinking cool drinks and looking out over the *zócalo*. Below us was a huge crowd. Inside Santa Prisca, the priests were celebrating Mass, but all the people could not fit inside the cathedral. Several *penitentes* stood patiently in the street below our balcony, with their arms outstretched under their thorn bundles. Small trickles of blood from the thorns had dried on their shoulders and arms. Their helpers gave them water and wiped their faces. It was said that prisoners in Taxco's jail were released if they carried a thorn bundle in the Easter procession.

Those who wanted to do penance but didn't want to carry thorns had another choice. They could walk on their knees on cobbled streets for the six kilometers. A few women did this, but mostly men. The hard part was that they weren't supposed to use their hands, so all the weight of their bodies fell on their kneecaps. Their supporters held their hands to keep them from cheating.

On Easter Sunday morning at sunrise, all the church bells in town began to ring in celebration of the Resurrection. After the silence of lent and Holy Week, the sound was glorious. All day long and for days after, the bells rang on the hour, off the hour, any time, up until the ringers went to bed. Fireworks burst.

The fireworks of Taxco had a spontaneity that made them more impressive than even the fireworks you see on TV. They seemed to be louder, and bang harder. Maybe there was more gunpowder in each firework. Almost any night of the year, one or two went off somewhere in town. On fiesta nights, they might go on for half an hour at a time, like popcorn. But there was a price for this exuberance. Two families made the fireworks in Taxco, and during the summer between our visits to Taxco, one family had blown up and died—father, mother, and all the children.

The most spectacular fireworks I ever saw were on a *castillo* built in the *zócalo*. The *castillo* was a thirty-foot tower frame made with bamboo, constructed in about eight stories. On each story was a bamboo and papier-mâché scene that was wired with fireworks, which provided the energy to make the scene

move. The action started at the bottom story, working its way around the scene so that its movement became more complicated and more extreme until the scene blew up. The fireworks then followed the fuse up to the next story and next scene, setting that one in motion.

On the first story, a man pushed a wheelbarrow. When the lit fuse came to him, his legs began running, and the wheel of the wheelbarrow turned faster and faster. Then the fuse went to the next story, where a donkey nodded his head and swished his tail, while the wheels of the cart he pulled began to turn.

The next story was a windmill with sails that turned round. After twenty minutes or so, the fuses burned their way to the top of the *castillo*. From each of the four corners of the tower, a small wheel spun up into the sky above the *zócalo*. People said that if you caught one of these wheels, called *palomas*, when it came down, you would have good luck. The next day I went up on the roof of our apartment to find that a *paloma* had landed on our roof, a wheel with a straw bird inside. I kept it for many years. *Paloma* means *dove* or *pigeon*.

Our cook had Sunday off and Mom cooked breakfast. She had brought a gallon of maple syrup and some cans of Canadian bacon from Maine. She had also bought some canned grits as we went through the South. On Sunday, instead of the usual eggs or cereal, we had Canadian bacon and fried grits with maple syrup. The parrot, *Perrico*, usually joined us. He sat on the edge of the table (that seated twelve) and side-stepped his way from person to person, begging for bits of food.

Perrico particularly liked scrambled eggs, but on this Sunday in spring, we were eating Canadian bacon and grits. I looked up to see my father at the end of the table with tears falling down his cheeks. Mom looked up at the same time. She rose and walked the length of the long table to my father. "Come, Bob," she said. They went into their bedroom and closed the door.

I don't remember much after that. Did Sal and I clear the table? Did we wash the dishes? These were our usual Sunday chores. We did go to our room. I think Mom came out and sent us down to my grand-parents' basement apartment. Did we come up to sleep? We must have. The next morning the doctor came, and as he went in we could see that my parents' bedroom was darkened, all curtains drawn. There were consultations.

Several mornings later, I saw my father in his bathrobe, going up the stairs to the roof. I hoped he was on the mend. It was on the roof that he had showed me how to do long multiplication and division, and how to find the area of a rectangle and the area of a triangle. I had not seen him in days. I asked him what he was doing, going up to the roof. "I need to wash my socks," he said. We had a woman who came twice a week to do our laundry, so my father did not need to wash his socks. I remembered Herman, who washed his socks in Bob's smelly pipe bowl. I went to find Mom. She went up to the roof and persuaded my father to come down.

My father left for a sanitarium in Mexico City. Mom explained that he had suffered a nervous breakdown and he needed a rest. He would be gone for a month. We needed to be brave and carry on. So, we did.

Sal went to the secondary school in another part of town from my school. Her school ran from 7:30 in the morning to about 2:45. My school ran from 9:00 to noon, returning at 3:00 until 5:00. At 3:00, Sal was all over for the day, when I had just gone back for the afternoon session in my school.

Because our schedules were so different, and because Sal was beginning to grow up, I knew little about her life. I knew she had a friend named Norma. That spring, she also had an admirer, Cuautemoc.

Sal says that one day she began to have trouble breathing and almost fainted coming home up the hill from school. She went to Mom, but Mom responded with her usual first line of defense that Sal would be okay. Sal went to Granny, who made Mom call the doctor. Sally had pneumonia. I was sent down to stay with Granddad, and Granny moved up with Sal. Granny nursed Sal through her pneumonia and caught it from her. Now Granny was sick downstairs, and she was in danger of dying. Dr. Miana prescribed antibiotics and mustard plasters for her chest, which had to be changed often. Did Mom do this? Granddad? Granny pulled through.

Granddad and I kept each other company while we waited. He spent one morning working on a formula to translate Fahrenheit temperature to Centigrade. Something like 5/9 plus 32 or maybe 9/5 minus 32. Anyway, he got it to his satisfaction. We played cribbage.

My father sent a few postcards. He was doing alright and loved us and missed us.

A rabid dog in town had bit someone. The town officials put out poison for the wild dogs and wiped them out. I was told not to let Finny eat anything in the streets. Bats regularly flew through Sal's and my room at night. These had always been creepy, and with the rabies scare were scary. We told Mom, but nothing happened. Putting screens on those huge doors would have been a major undertaking. No one had screens in Mexico.

I cut school one day. Someone told my mother they had seen me, and my mother gave me a stern lecture.

After a month or so, my mother told us that my father had left the sanitarium and had gone to Zijuatinejo to get better. Zijuatinejo is a town on the Pacific Coast north of Acapulco. It is now a regular tourist destination, and was once the home of the LSD guru Timothy Leary, but then it was almost unknown. My parents arranged that Mom and Sal and I would go to Zijuatinejo to join Bob, and we would spend a week there on the beach.

We drove from Taxco to Acapulco, and stayed the night at one of the Acapulco hotels. In the evening, we went to a neighboring hotel to see the boys dive from the cliffs into the water to recover coins. My mother was sick with *la turista*, and was on the toilet all night. Sal remembers that the toilet had no real plumbing, and was just a hole over the cliff and the ocean. Sal says she remembers feeling so sorry for Mom, who did not have a proper toilet to be sick in.

In the morning, we took a plane, which was Sal's and my first airplane flight, to Zijuatinejo, where we were reunited with my father. It was wonderful to see him again.

There were no real hotels. We stayed in thatched huts on the beach—Sal and I in one, Mom and Bob in another.

Even though the huts were primitive, there were real toilets. In our hut, I discovered an old *Reader's Digest*. After reading "This Is Joe's Stomach" and learning all the possible things that could go wrong with a person's stomach, I wondered if I had cancer. My stomach had been aching.

The next day, we swam on the beach in front of our huts. I got a terrible sunburn, which slowly healed during our stay. We walked down the beach to see the sharks the fishermen had pulled up on the beach: hammerhead sharks twenty feet long, and turtles eight feet long. There was a factory that made dog food from the sharks.

Sal and I went waterskiing for the first time and watched people ski-sailing. One day we went with an older American woman on a picnic by boat to a beach on the other side of the bay. I don't know who the woman was, but she was the only American and only English speaker other than our family I remember seeing in Zijuatinejo that week. At that beach, I got caught in a wave and thought I was going to drown before it released me. The beach was known for its dangerous undertow.

One day we went fishing and caught horse mackerel. One night we went net fishing for little six-inch fish with green bones. They were served deep fried—heads, guts, and all—and tasted wonderful.

It is only now that I realize how carefully my father planned that week: sunning and swimming on the beach, seeing the sharks and sea turtles, waterskiing, trolling for horse mackerel, a picnic on the far side of the bay, night fishing for fish to deep fry.

After a week, we left our huts, and packed our car. My parents had hired someone to drive it from Acapulco to Zijuatinejo. My parents bought a two-foot bunch of finger bananas and some horrible sesame seed candy in the market for snacks on our trip. We drove back to Taxco, and then home to Maine.

Entering Adolescence

After our second year in Mexico, my family returned from Mexico to Maine and then New York. That summer, Sal crewed for Johnny, a boy who raced a sailboat in the races at the Bucks Harbor Yacht Club. This was much more sophisticated sailing than the messing around we had done with Mom in our small sailboat. The boats were gaff-rigged sloops with Herreshoff lines, built around 1900. They were called Dark Harbor 12s, from where they were built and because they were twelve feet at the waterline. But they were much bigger than they sounded, because they had a huge overhang on the bow and stern, so that twelve feet at the waterline became eighteen feet on deck. Or as they say in the boating world, eighteen feet overall. Even in the 1960s, when Sal began sailing them, these boats were venerable.

Sal learned a lot from Johnny. The next summer, he went off to work, and his family offered to charter (rent) their boat to us. Sal skippered and I crewed *Wee Robin* in the yacht club races, and we won. Sal passed on to me much of what she had learned.

In the fall, we returned to New York and had our dental check up with Dr. Johnson, and I had five cavities, payback for all the candy I had eaten in Taxco the winter before, and maybe the milk I had not drunk. I was now in sixth grade. I liked my teacher and friends, but I had spent much of the last two years in a foreign country. My father had had a nervous breakdown. I had learned that the mother of a friend had become an alcoholic. I couldn't begin to tell my friends about my experiences.

I developed a crush on the cute boy who sat next to me. I was pretty smart in English and history. I was also pretty smart in arithmetic and science, but the Raymond who sat behind me was really smart.

My friend Dolores and I were especially good in reading. To keep us amused, the teacher gave us dispensation from the regular reading assignments. Our assignment was to read the grade-level reading tests for our year and the years ahead of us, by the month, and answer questions, as far as we wished to take it. I got to the eleventh grade and quit. Dolores got a little farther. Years later, she told me that her mother suffered from schizophrenia: Dolores also had experiences she couldn't talk about.

At recess, I sometimes played the old games with the other kids: dodgeball, hopscotch, jump rope, jacks. Other times, I went off by myself and wandered around the far reaches of the school yard. I felt brooding and sad. This is what it is like to be a teenager, I thought. I was changing, and I wasn't sure I liked it.

My period started that year, when I was only eleven. Nowadays, with hormone disruptors, getting your period at eleven is not unusual. When I started, I had never heard of menstruation. My mother was shocked, and felt bad for not having talked to me. I was ashamed.

Sally was not adjusting back to her old school in ninth grade. Because of her time in Mexico, she was different, at an age where it is dangerous to be different. She was called Husky McCluskey. Sometimes kids called her on the phone and bullied her and said she was gay. My parents heard one of these calls, which helped them decide to move away from the area.

My father was painting finely graded color samples like the ones you see in paint stores. He spent a year on this work off and on. Nowadays, you could generate his careful sequences on a computer in an afternoon, with a bunch of clicks and an accurate printer. But who would need to? It is already on the computer. But perhaps he improved his visceral understanding of color from this painstaking exercise.

Viking was considering publishing a geometry book for grade school children and asked my father to propose some illustrations. He learned how to make geometric solids out of paper, and taught me how to make a hexagon solid. He was making decahedrons and dodecahedrons with raised stars on each face. Then he drew them. I can't find the picture of the hexagon solid that was tacked on the wall of his studio in the boathouse for so many years. Some things are lost.

Bob had studied dynamic symmetry in art school, and now he explained the rudiments of dynamic symmetry to me. He taught me about the golden rectangle and the pentagon, which he said are both based on the proportions of living things. He explained that if you used the proportions of dynamic symmetry in your pictures, your pictures would be more satisfying to look at. He also said that most Greek and Renaissance art is based on dynamic symmetry. Recently, Sal told me that Egyptians, Indians, Byzantines, and Russians also used dynamic symmetry in their art. Viking decided not to publish the geometry book.

The next summer, Burt Dow, a friend of Ginny and Buck Walton on Deer Isle, decided that his old boat, the *Tidely Idely*, was getting too unseaworthy to use. My father bought it from him and towed it with our powerboat to the island, where it sat on the boathouse beach for a summer. Bob made sketches of it.

Burt said he had been a "deep water man" and sailed around Cape Horn. Now he was retired, and lived on the Dow Road on Deer Isle with his sister Leela and his brother Frank. They kept chickens, rabbits, sheep, and a horse, and had a good garden. My father began work on *Burt Dow: Deep Water Man*.

In this picture from *Burt Dow*, Burt is tossing a popover to his friend the Giggling Gull. Mom learned to make popovers one summer and made several delicious batches. Then one batch flopped so badly that no one would eat them. She said she gave a popover to Finny, and even he wouldn't eat it. He took it out to the woods and buried it. My father is teasing my mother with the popover in this picture.

As Bob wrote and illustrated *Burt Dow*, he said that he had a problem with the whales that Burt met on his deep sea fishing trip. My father was an accurate anatomist, and he researched what the various species of whales looked like. But none of the whales, even the sperm whales, had quite the look he wanted, so he decided to draw the whales of his imagination. *Burt Dow* was, after all, a fish story.

Next summer, my parents decided that Sal and I would go to a boarding school in Switzerland for the following year, while they traveled in Europe. Mom researched various schools. I voted for the school that offered horseback riding, but Mom vetoed that idea. She said that the school offering riding was a finishing school, which was not what my parents wanted for their daughters. It was also expensive. My parents chose a school in the mountains above Lausanne, *l'Institute la Villan*.

My mother ordered trunks for us to take to school in Switzerland, and we watched my father paint our names on them. He said that he liked to use a modified Roman lettering in his work, as it was attractive and readable and appropriate for most uses. He used it on the covers of his books and our trunks. Mom ordered name tags and found a woman to sew them on our clothes. She bought about twelve boxes of Kotex and packed them in our trunks: shame and humiliation. That year she also developed an allergy to lobsters.

In September, we sailed from New York on the *Rotterdam*. I think it was its second voyage. I had my twelfth birthday during the crossing. Mom alerted the chefs, and they made me a birthday cake frosted with about a half pound of marzipan. Such a treat!

We had a calm crossing, with only one rough night. Except for that night, I was surprised to discover that, if we could have carried enough gas, Sal and I could have crossed the Atlantic in our twelve-foot speedboat without a problem.

In Liverpool, we picked up a British Hillman car my parents had bought, and traveled through England. We ate Yorkshire pudding and roast beef and saw thatched cottages and Stonehenge. In London, we saw The Changing of the Guard, inserted money into a heater in our freezing hotel bathroom, and had the best Indian cooking I have ever eaten. I started reading *Tarzan of the Apes* and found it too dull to continue.

We took the ferry to France. We saw Percherons and medieval castles and lovely chateaux. I got my period, and France did not have public bathrooms along the road. This was a major problem for a shy twelve-year-old.

We weren't supposed to drink the water or the milk, so my parents bought bottled cider for Sal and me, and wine for themselves. The cider was awful. My parents finally tasted it and discovered it had a higher alcohol content than the wine, so we all ended up drinking wine, which I didn't like much either. Times have changed.

Anyway, Sally knitted. My father was irritated at our lack of appreciation for culture. I was exhausted by my menstrual embarrassment and the minimal bathrooms. Maybe Sally had her period too. We didn't discuss such things.

We came to Geneva, Lausanne, and Montreux, and began to climb. The beautiful Swiss mountains we had seen in pictures were suddenly around us. We drove up switchbacks even more impressive than the mountain roads in Mexico, until we came to our school. My parents kissed us good-bye and went on their way. Maybe it was as exhausting for them to be in close quarters with their young teen daughters as it was for me to be with them. Actually, my trouble was with my father. Before my puberty, I was closer to him. After puberty, I was closer to my mother.

I liked the school. About two thirds of the kids were Americans. A large group of students had parents who were teaching for a year in Indonesia. Because of the revolution against Sukarno, the parents decided that the children would be safer in Switzerland. Also in the school were several kids of professors

on sabbatical, several army brats, the daughter of a high Israeli official, a very rich boy from Burma, two very rich brothers from Venezuela, and several daughters of odd-lot parents like ours, wandering around Europe and Asia. Almost everybody was new, so there were no cliques to break into, and we remained pretty clique free.

Meanwhile, my parents were traveling around Greece. Later they told us that, since they did not speak any Greek, my father drew pictures of things they needed.

My father drew boats and fishing villages.

He had developed an interest in mountains in Mexico. Now, he seemed to be tuning in to mountains as the embodiment of the bull culture of Crete. Also, Zeus turned himself into a bull to carry off Europa.

Over Christmas, Sal and I went to Geneva and stayed with a family my parents knew. I read Nancy Drew. We went to the dentist to have our teeth checked, and I had to go back to have a tooth filled. We caught a plane,

with a change of planes in Rome, to Taormina, Sicily, where my parents were staying. Without speaking any Italian, Sal got us from one Rome airport, across the city to another Rome airport, at about 11:00, on a cold, black, rainy, winter night.

Taormina was beautiful, with bare, rocky hills in brilliant, chilly sunlight and blue sky and sea.

We saw the ancient Greek amphitheater, without any guards or gates, free for the exploring.

Sal and I played tennis. My parents lived in an upstairs apartment, with steps up the outside of the building from the street. At the foot of the stairs was a pig's head filled with aging headcheese. Mom sent me across the street to the cheese shop to buy some provolone. I talked in Spanish, they answered in Italian, and we got on fine.

Sal acquired two admirers, both named Mario. My father named them Mario the Vecchio, the Elder, and Mario the Giovane, the Younger. I didn't know this at the time, but this naming was a takeoff on the naming of classical artists such as Holbein the Elder and Holbein the Younger. Young Mario was only a couple of years older than Sal, maybe eighteen. The older Mario must have been over thirty.

My parents—and Sal herself—didn't think she should go out on a date by herself, so Mario the Giovane took the whole family on a picnic to the beach. Mom helped with the food. The young Mario hoped to go to America someday, and asked if we knew his friends in Argentina. Mario the Vecchio took us to a night club, which I found pretty dull.

I read *Topper*, about a guy haunted by his dead, ne'er-do-well friends and his dog, and laughed harder than I ever had laughed in my life.

We went to Catania, and visited the Ear of Dionysus, a cave with interesting acoustics. Then my parents put us on a plane back to school. I felt the parting much more this time and cried in appreciation of my Mama.

At school, we learned that our headmaster and school owner had had a heart attack and died over Christmas, but his family decided to carry on.

The second term was not as happy as the first. I was moody, and wanted to brood by myself instead of being with my friends. I read a book about the Jews in the Nazi concentration camps. Their deaths were horrible. Even more horrible: their skin was used to make lampshades. I was in shock and woke up in the morning with my head at the bottom of the bed and my feet at the top. The concentration camps had been closed only fifteen years before.

My roommate, Eden, and I figured out that you could climb up on top of the wardrobe in our room into a small space just below the ceiling. Even though it was in plain view of the door, you could crouch there motionless, and people who came in would not see you. One day, instead of going to gym class, I climbed up on top of the wardrobe. Dr. Lejri, the French teacher, came to find me, looked right at me, and went away.

Later in the spring, I walked by myself along the cow paths near the school, feeling melancholy. I became friends with a serious, intelligent girl who was older than me, and we had deep discussions. Someone had a ukulele. I learned to play "Swing Low Sweet Chariot" and "Hang Down Your Head, Tom Dooley."

For spring break, my parents picked us up at school and drove us to the coast of Spain. I only remember the lovely aqueducts — the land, which was similar to Mexico but more barren; and the cold, new, ugly hotel. After that vacation, my parents went back to Maine. At the end of the school year, Sal, who had just turned sixteen, capably managed the plane flights and customs from Geneva to the Azores to New York City to Boston, where our parents met us. I was again impressed with my sister and grateful for her leadership in scary places. We came home to the Island for the summer.

The summer we got back from Switzerland, Sal went off to work at Les Chalets Francais, better known locally as the French Camp. I raced in the sail boat races at the yacht club in another Dark Harbor 12, the Blair Ann. I often came in last, and even though she was known as a slow boat, it was a comedown after Sal's and my success when we sailed and won in the Wee Robin. Still, I was becoming more confident as a skipper.

One day, I went to Bucks Harbor to meet my friend Sarah. We had eaten the sandwiches our mothers had packed us for lunch, and decided to go sailing in her boat. The wind had been blowing as I came from the island in the speedboat, and we wondered if it was too windy to sail. But, we hated to be scaredy cats, so we set out. As we got further from the lee of the land, the wind kept increasing, and the swells got bigger. Five minutes out of the harbor, the boat was heeled over hard. When the boat is over that far, the rudder is more horizontal than vertical. It moves up and down more than it does from side to side, so the boat becomes difficult to steer. We were pretty frightened, and decided to come back to the harbor.

I was a year older than Sarah. Usually that didn't matter, but now I was at the tiller, and my extra year made me feel responsible for her.

I had decided that year that God probably didn't exist, but that day, I prayed to Him-Her-It anyway: *Oh please, don't let us drown, but if it has to be one of us, please take me and not Sarah.* I could not imagine facing my family and hers with Sarah drowned. A calm came over me, and we sailed safely home.

After that, I kept an open mind about God. If I was going to pray to God when I was scared, I needed to be respectful of God when I wasn't.

High School

The year we got back from Switzerland, as fall approached, I began to dread going back to school. We were not returning to May Massee's house and our old schools. My parents had decided to send us to Fox Lane School (a junior-senior high School) in Bedford, New York, which had an excellent reputation. Our Swiss school had taught us very well in some subjects, but poorly in others. When we were younger, we could pick up what we needed to know on our own, but with Sal going into eleventh grade, she needed to be mainstreamed for college.

Our days of fall home schooling on the island were over. On the first day of school, Mom dropped us off at Fox Lane. It was a shock. We had come from our Swiss school with fifty students ranging from nine to eighteen. Our other schools were also small. At Fox Lane, there were more than 1200 students in seventh through twelfth grade, with over 200 kids in my class. My previous schools had been old, small, used, and comfortable, with wooden desks that were marked and carved. Fox Lane was new and huge, with plastic-metal desks, shiny tiles, and modern curves. The chairs were molded plastic in turquoise and orange.

I had been to three schools in three years and adapted well to all of them, but I didn't adapt well to Fox Lane, although Sal did. Maybe I was the wrong age. Sal had not been able to adapt back to her school when she returned from Mexico in ninth grade. Now I had trouble adapting to Fox Lane in the eighth grade.

Fortunately, I made friends with Susannah Price right off. Over the next couple of years, I became friends with three other girls: Mary Ann, Suzy, and another Jane. I was friendly with a few other kids, but we were isolated friends in a sea of acquaintances and strangers.

It was not all bad. I had learned to play the ukulele in Switzerland. Mom showed me that guitar chords were the same as ukulele chords with a couple of extra strings. She taught me some more chords, and I was launched as a guitar player. Many of my friends were also learning guitar, and we learned the folk songs of the sixties.

I figured out the chords for the songs of my childhood and discovered that you can play 90 percent of the songs ever sung with just three chords. Some of us tried to learn Travis picking. I loved Mississippi John Hurt, Dave Van Ronk, The Jim Kweskin Jug Band, and John Fahey. Mary Ann's brother, Justin Case, and his friend Loudy Wainwright played in a band they called The Midnight Five. They sang, "Long Tall Sally" and "Splish Splash. "

Sal and I had learned how to ski in Switzerland. The Prices had learned in upstate New York. Now, Susannah's father, Mr. Price, and my father gave us occasional weekend rides to nearby ski areas.

As I have mentioned, Mom had been a children's librarian in New York City before Sal was born. Now she went back to work at a local library, which was a pleasure to her.

Another Jane, who with her husband, Bob, was friends with my parents, opened a dress shop. In exchange for my father doing artwork for the shop's advertising, Jane gave Mom, Sal, and me discounts on our dresses. Mom learned how to dress and style her hair fashionably.

Edee's father divorced her mother and remarried. To try to create goodwill in his new family, he took his new wife, Mimi, and Edee and me to the 1962 Seattle World's Fair. The trip was fun for me, but a failure in improving divorced family relations. Edee was not mollified.

Still, it was a wonderful trip. I remember hearing Hawaiian guitar music for the first time and going to the top of the space needle. We ate smoked salmon, took a ferry from Seattle (or was it Vancouver?) to an island, and stayed there with friends of Edee's father.

Edee's new stepmother, Mimi, wisely kept a low profile. Edee simmered. I played the friendly guest. After a weekend, everyone was relieved when Edee and I were put on the Canadian Railroad to Lake Louise in Canada.

We had a tiny cabin on the train, a black porter who looked after us so we wouldn't get lost (thanks), white tablecloth meals with silver dome covers to keep them warm, and glorious views out of every window: trees, streams, rocks, mountains. At Lake Louise, an old friend of Bill's acted as chaperone and babysitter for Edee and me. We were fourteen, too old for babysitting and too young for chaperonage, but

we needed someone to look after us. Our minder was a good sport, who left us pretty much alone, eating dinner with us once a day. Edee and I reveled in Five Star hotel service, with room service every morning: bowls of oatmeal, toast, eggs, Canadian bacon, all covered with silver domes. Several times we went out and rode horses around the beautiful lake.

At the end of a week, Bill and Mimi came to pick us up and we took the train back to New York. Bill and Edee had to catch a plane back to Atlanta, but Bill's new bride, Mimi, earned my friendship when she stayed behind to guide me from the hotel to Grand Central Station. There she made sure I got on the right train back to my parents.

The following year, Edee's mother went on a tour of Paris and, along with two hundred other people from Atlanta, was killed in a plane crash. Maybe because of her troubles, Edee reconsidered her Black Fairy persona, and balanced that Fairy with gentleness.

When I was in tenth grade, my father's friend Mort Schindel made a movie of *Homer Price and the Doughnut Machine*. Mort's previous movies had been of picture books, which he had filmed directly by panning the camera across the pages of the books. *Homer Price* was a "chapter book," with only a few illustrations, so he couldn't use his usual method. Mort had to find people to write a screenplay, build a set, find a cast, and whatever else moviemakers do.

The movie only involved four or five main characters—and, of course, the doughnuts and the machine that made the doughnuts. We went over to see the set with a lunch counter and the doughnut machine. The floor and counter and tables were covered with hundreds of stacks of doughnuts a couple of feet high. They had put dowels through the doughnut holes to keep the stacks from tipping over.

On the day they filmed the crowd scene, my father and Mr. Price, Susannah's father, went over to Weston Woods Studios to take part in the movie's doughnut orgy. Mr. Price shared the same last name as Homer, so he had a particular interest in the film.

After the movie was filmed, Mort gave Bob one of the doughnut machines, and it sat in our garage in Maine for years. Bob thought of someday giving a doughnut party, and adapting a doughnut recipe to make unsweetened garlic doughnuts: he liked garlic in practically everything. He even made garlic peanut butter, which was terrible. But he never got around to a party. The doughnut machine was temperamental and would have needed tinkering and more parts to make it run again.

In 1964, there was a World's Fair in New York, and my mother invited Edee to visit us and go to the fair. It was good to see Edee, but I didn't think much of the Fair. Many of the exhibits were still unfinished, with construction mess all over. There were long lines and the weather was hot and sticky.

But on the day we took Edee to catch her flight home, Mom and I came out on the pavement with her while she waited to board. There was a large circle of people, mostly black, between us and the plane. As we approached, the two people nearest us turned and parted. They beckoned us to join the circle,

which we did. Someone was just finishing a speech, and then everyone, including us, joined hands, and we began to sing. "We shall overcome." We kissed Edee good-bye, and watched the plane take off. Mom said that Mrs. Martin Luther King had been saying good-bye to her friends, and, like Edee, was going home to Atlanta. I never forgot the feeling of welcome and generosity I felt from that circle of people. We shall overcome someday.

Burt Dow was the last book my father wrote. The last books he illustrated were *Henry Reed, Inc.* and its sequels by Keith Robertson. If Homer Price had been reincarnated in the 1960s, and a couple of years older, he would have been a lot like Henry Reed. I posed for Bob in a couple of these books.

Many years later, Bob said that he stopped asking me to pose because I became resentful of being asked. I was somewhat hurt at his claim, because I was proud to pose for him. But he was right on an existential level. When I was a kid, I sometimes became self-conscious when my father looked at me. I had the feeling that he saw much more clearly than most people. But I felt that his gaze was mostly kind. But when our family was reunited after a year apart in Europe, I felt that he saw me as a stranger. I felt more self-conscious. I felt like an object and diminished.

I myself had become more watchful of the world. I was no longer a wide-eyed child, but a critical teenager. I loved and respected my father, but I felt cut off from him. But my real alienation came from my dislike of my modern school and the modern American culture that seemed to be the future of the world. Did my father, my parents, really expect me to adapt to this soulless modern life? Little did anyone know that my feelings were similar to the feelings of many in my generation, the first stirrings of the counterculture.

For a couple of years I had a fantasy that I lived a hundred years ago. Before I went to sleep at night, I saw myself going into the woods with an axe and saw and building my own cabin out of logs. I notched them with a hatchet, and raised them into place for the walls. I built the chimney out of clay and rocks, and for the roof, I cut poles crisscrossed and covered with birch bark. I made a cozy home. I felt sort of silly. Nobody built their own houses anymore. Years later, I came to Maine, and I really did build my own house, not out of logs, but out of two-by-fours and boards.

My father had often claimed that he learned to See in art school. Now I learned that Seeing was a complicated business. When I was watched, I became different from when I wasn't watched, so Seeing was not a passive process, but one that changed the person seen. I also learned that Seeing could be a two-way street. The person Seen also had power to See the See-er. And the See-er in turn was changed by being seen.

In any case, Bob began a new career when I was in tenth grade. He began to make puppets. With the help of his friend Mort Schindel, he hoped to make them into a television show.

Over a number of years, the following facts emerged.

There were three puppets who were friends: a Mouse, a Mole, and a Pigeon who all lived in the back of a school bus. The Mouse had no name, and Bob said little about him. The Mole was named Twenty Twenty. He wore dark glasses and was presumably almost blind, since he was a mole. He might also have been a spy, since he was a mole. Since moles lived underground, he might have been in the underworld of crime. The pigeon was named Mr. Pinkerton.

"Why do you call him Mr. Pinkerton?" I asked.

"Haven't you ever heard of a Pinkerton Man? They are detectives."

I learned later that Allan Pinkerton was a detective who founded the Pinkerton Agency in 1850. His motto was "We never sleep," with a logo showing a wakeful eye. Since Pinkerton's was a private detective agency as opposed to a government investigative organization, his agents came to be called private eyes.

Bob started working on the Mouse, and I made his first set of clothes. Bob soon decided that the Mouse was too small to work on easily (he was about six inches high), so he began work on the Mole, who was about a foot high. I made the Mole's first set of clothes too.

There were actually two of each of the puppets. For Twenty Twenty, one dressed Mole was onstage, seen by the audience. He was connected by strings in a hollow brass rod behind his legs to another skeletal undressed Mole underneath the stage. When the puppeteer moved the hidden Mole underneath the stage, the Twenty Twenty on stage made the exact same movements. The mechanism worked with small brass-toothed wheels, which Bob made on a lathe. The wheels were linked to each other like clockworks, and then attached to nylon fish line, which ran through pulleys and through the connecting rod to the pulleys and wheels of the puppet at the other end.

Twenty Twenty could move almost any way a human can: nod and shake his head, move his head in circles, move his shoulders forward and back, up, down, and around. He could do the same with his elbows and his wrists, hips, and knees. His eyebrows rose and fell and waggled. His mouth could pull up in a smile and pull down in sadness.

He was a natty dresser: Bob said he was a Mole about town. He wore large dark glasses, like a celebrity, criminal, blind person, or spy.

Bob constantly took Twenty Twenty apart and put him together again, improving his movements. Bob never went back to the Mouse or forward to Mr. Pinkerton. He said the Mouse was easy, and that once he had Twenty Twenty perfected, he could reduce the size of the parts for the Mouse. He said that Mr. Pinkerton was tricky, because birds have wings, and the question was how far to modify the anatomy of real bird wings so that Mr. Pinkerton could grasp with his wings as we do with our hands.

My parents were friends with the Prices, parents of my friend Susannah. One spring, the Prices had a pool painting party. My father disappeared. We discovered him putting the finishing touches to a mural on the inside walls of the ladies' bath house. Women with big hair and big tits flung their bikinis to the wind, while others held their martini glasses high. Sometimes my father seemed like his old skylarking self. Other times he was withdrawn.

There was a restaurant near the Prices' called Nino's that was never open. But on Sunday mornings, about five black Cadillacs gathered in the parking lot for a couple of hours, and then departed. The place was deserted for another week. People in the neighborhood, including my father, speculated that the restaurant was owned by the Mafia.

Later, when I was in college, my father came up for father's weekend, and took me out to a restaurant. When we walked in, my father whispered: "Mafia!"

"Oh, Bob."

We were late, and after a pleasant, leisurely dinner, we were among the last people to leave the restaurant. When we came out the door, the parking lot was empty except for my father's Volvo and about twelve white Lincoln Continentals. My father laughed. "I guess in New York they have the black Mafia, and here they have the white Mafia."

My life became divided. In New York in high school, I felt like a stranger and a misfit. I walked stiff-legged past the study hall, feeling the eyes of other students follow me. I did okay academically, but with more than two hundred students in our class, the competition was much fiercer than any I had ever known. I was becoming increasingly self-conscious, which made writing difficult. Instead of trying my best in school, I began to see how well I could do by doing less. I started getting by.

In Maine, I was popular, and I became a solid member, even a belle, of our group at the yacht club. I was friends with about everyone. Boys asked me out. Bill asked me out regularly, and we became fond of each other.

One race day, I asked Edee to crew for me. As race time approached, everyone began to worry about the wind and wondered if the race committee should call off the race. They decided to go ahead with it. I asked Bill if he would go along with us as an extra crew. Edee is a brave person, but very light boned and slender. Fortunately, Bill came with us.

As we were coming home on the final leg of the race, the boat heeled way over, just as Sarah's boat had in the heavy wind that scared us a couple of summers before. Again, steering was hard. This boat's boom was a little lower on the mast, which made seeing under it very difficult. We had to crawl down the forty-five-degree deck every couple of minutes to see if anyone was in our way. At one point, I crawled down the deck to see a boat about fifteen feet away.

It was way too late to do anything but yell, and I was too stunned to do that. They had not seen us. They had the same problem as we did: they had to crawl down the forty-five-degree deck to see other

boats approaching. Like us, they hadn't crawled down recently enough. The first they saw of us was our extreme pointed bow slicing through their sail like a huge spear point. Our boat was smaller, and it rode up on their deck all the way to our keel, at which point we slid back down again. Our bow ripped their mainsail enough for me to see my sister staring at me from the other boat. I had thought she was ten miles away in the French Camp, but she was crewing on that boat. I heard later that our sharp bow had missed her head by about five inches.

When our boat slid back down into the water, I thought we were going to be safe, but one of our jib clips caught on the rigging of the other boat. They were out of control, jibing around with great swings of their heavy boom and sail. Every time they jibed, they whipped our smaller boat around after them like a duo crack the whip. We jibed in turn. Jibing is the most dangerous maneuver in high winds, and our two boats were doing them repeatedly. After about the second jibe, Bill was able to get up on the bow. He hung on while we executed our third jibe, and got our jib clip detached from their rigging. Everything calmed down then. The other boat was towed back to harbor, with a hole in their sail and a couple of feet of their bow pulled up by the weight of our boat on their boom. We sailed home on our own, with our boat totally unharmed.

Insurance fortunately covered the damage to the other boat. I was at fault, because our boat was on the port tack. I never felt as confident in boats after that. I could have killed my sister.

For two years after that, Dolly, a kind woman who owned a modern class of boat called a Day Sailor, asked me to skipper for her. We were a good team, and we won lots of races at the yacht club. I was even chosen with Sarah and Annie and Ann to represent the club in the Sears Cup races against other yacht clubs in Maine. We won one round, but lost in the second round. This level of competition was more serious and cutthroat than I wanted to be.

I loved the beautiful land and water and my friends in Maine. I was happy. But I was becoming aware that Maine, as I knew it, was not the real world. I was being groomed to become some sort of professional in the vicinity of New York or Boston, with two weeks of vacation a year in Maine. After twenty years, I might get a month's vacation. Fox Lane High School, with its ugly plastic furniture, padlocked lockers, smelly gym rooms, huge numbers of students, crowding, computerized class schedules and report cards, was the wave of the future. Growing up looked increasingly grim.

That summer, Edee and I became junior counselors at the French Camp on Deer Isle.

At camp, I learned how to hypnotize people, but that is another story.

Edee had spent a couple of summers walking a half-mile path in the night to visit her boyfriend at his cabin in the woods. Now, she snuck out of camp, walking a half mile to meet him at the nearest road. One night, while she was gone, we heard a horrible scream in the night. There were about eight junior counselors in our off-duty cabin. We were frozen for a moment, and then decided that the safest thing was to run in a group to the senior counselor's cabin and confer. So, we did. Beaver, the riding counselor and horse wrangler, was the oldest counselor and had the longest history at the camp. He said that what we heard was a cougar, which had been coming down from Canada for a number of years. Someone some years ago had left food outside the cook cabin, and the cougar had found it. It had been returning off and on ever since in hopes of another good meal.

Edee missed all the excitement, and she returned without trouble. But the amazing thing is that, even after she heard the cougar story, she continued her half-mile, two-way walk to meet her boyfriend in the woods at night. Now, many years later, with the benefit of the Internet, I have listened to the sounds of cougars, lynxes, bobcats, coyotes, foxes, fishers, coyotes, and snowy and great horned owls. I believe that the fox I have heard on the Internet is the closest to what we heard that night. But what we heard was higher and louder and more drawn out than the fox calls, and much scarier. And it only happened once, not several times in a row.

Some years later, my husband and I went on a canoe trip to Kejimkujik Lake in Nova Scotia, and again we heard a sound that put terror in my soul. I looked out to see a huge owl in a nearby tree. So, who knows? I have lived in the woods on Deer Isle for more than thirty years and have never heard sounds like we heard at the French Camp and Kejimkujik Lake. I have heard coyotes and owls and foxes on their spring mating run, and heard fishers killing a cat, but never those unearthly sounds. Anyway, Edee was brave.

In New York, I began reading a book called *The Ginger Man*. It was too depressing to finish, but I was struck by the prayer of Sebastian Dangerfield:

And dear God
Give me strength
To put my shoulder
To the wheel
And push
Like the rest.

This became my prayer. I had begun to feel that I didn't have the strength to do what I was supposed to do.

In my chemistry class, I read Rachel Carson's *Silent Spring*. Her book also depressed me, with its description of the destruction of the natural world by DDT. Also, in my chemistry class, the teacher passed around a piece of mercury. He wanted us to experience an element that was neither liquid nor solid. Someone dropped the mercury near my desk. We picked it up, and didn't worry about it much.

Our life in New York was, from most perspectives, enviable. Our school had an excellent reputation. We lived in Bedford, a well-to-do suburb of the city, with deciduous woods and handsome houses tucked into the landscape. Our house was beside an old mill pond, with the dam twenty feet from my father's studio. Across the dam was a picturesque, well-maintained colonial mill house. Ducks and geese and swans swam on the pond. During mating season, the male swans saw their reflections in my father's studio windows, and thought these strangers were challenging their territory. The swans attacked his windows, until Bob learned to pull the curtains. The swans no longer saw their reflections and went back to the pond.

For some reason, Mary Ann's mother had committed Mary Ann to attend a Friend's Meeting. I think it was on the John Jay estate. One morning in spring, Mary Ann asked Susannah and me to keep her company at the Meeting. Dreading a church service, and dressed up more than we wanted to be, we piled into Mary Ann's mother's car, and off we went. The trees were coming into leaf, and the air was soft. We climbed the quiet mountain road through the woods to a tiny chapel overlooking miles of beautiful countryside. We entered the building to a Quaker meeting, with maybe a dozen people. We were the only young people. We sat in silence. And sat. And sat. I tried to think uplifting thoughts, but it was a struggle. My feet kept booming on the pew when I shifted position. We sat on. Finally, someone said, "Consider

the lilies of the field. They toil not, neither do they spin. Yet, Solomon in all his glory was not arrayed like one of these." I was uplifted.

It wasn't until I was in my thirties that it occurred to me that the man was probably talking about Mary Ann, Susannah, and me. We were lilies, unaware.

We had the normal teenage adventures, but they took an increasingly dark turn. Mary Ann and I snuck out to a party one night. That night, a boy we both knew got drunk and totaled his car. He told the police that Diana, another friend of ours, was with him. The police searched the woods for her. Fortunately Diana had the sense not to drive with the boy when he was so drunk, and made her way safely home.

Sally was in college. She participated in a sailing tournament on the Charles River in Boston and caught pneumonia. My parents went up to visit her, while I stayed with Susannah and her family. My sister was in danger of dying. A week later, Sal was on the mend. The next time my parents went to visit Sal, I had an illegal party in my family's empty house. Someone burned a cigarette hole in the rug, which my parents discovered when they came home. I was reprimanded and grounded.

A short time later, another boy, who had the reputation of being one of the smart, responsible kids in our school, was killed in a car crash. In my senior year, friends began to talk of people they knew who were doing heroin. When I went to Maine the summer after my senior year, Mary Ann wrote me about three boys who had cracked up on motorcycles in three separate crashes. I felt glad to have escaped from high school without harm.

Fame

After I graduated from high school, my daily life with my father came to an end. As I have lived my own life, and thought about his, I have come to see themes that were important in my father's life. One of them was fame.

Time of Wonder seemed to be the jumping off point in my father's journey to fame. Before then, he was known in the field of children's books to librarians, school teachers, and children's authors and illustrators, but after that, he began to be known more generally. My father had won the Caldecott Medal with *Make Way for Ducklings* which is awarded by the Association of Library Service to Children, a subsidiary of the American Library Association, to "the artist of the most distinguished American Picture Book for Children published in the United States during the preceding year." With *Time of Wonder*, he won it a second time. He was the first artist to win it twice. Since then, I believe four other artists have done so.

When we came back from Mexico, my sister received a letter from Cuautemoc, a boy she had met at her school there. It was addressed to Sally McCloskey, Penobscot Bay, Maine, and the post office managed to deliver it. That was probably my first understanding that my family might be known in the larger world, and that my father's reputation was probably the reason.

> March 25, 1985
>
> Dear Mr. McCloskey,
> I really like your books.
> My favorite book of yours
> is Time of Wonder.
> I like your drawings
> and writings.
>
> From,
> Brendan

> March 26, 198_
>
> Dear Mr. McCloskey,
> I love all your
> books. My favorite
> book is One Morn-
> ing In Miane. I
> Homer Price the
> chapter Donuts
> was funny. I
> have two brother.
> There names are
> Jason and Andrew.
> Jason is 11 years

> old and he is in
> 6th grade. Andrew
> is in nursery
> school. I saw
> a part of you
> in the news. My
> mother is pregn-
> ant. I like horses
> Do you?
>
> From,
> Allison
> King

Later that same summer, a sailboat came in to our cove one late afternoon. A couple came ashore, found my father in his studio, and introduced themselves. My father must have taken to them, because he brought them up to the house, where Mom invited them for drinks. They stayed to dinner, and I seem to remember we ate lobster. They must have brought the lobster as a house gift, since we wouldn't have had it lying around. We sang songs, and they taught us the second and third verses to "Jamaica Farewell." It was a pleasant evening. Anyway, we were impressed that these people had found us by reading *Time of Wonder*, tracing us to our island by the names of the islands mentioned in the book.

My father also received fan mail, which arrived every so often in packages from Viking Press. Most letters were from school kids who wrote to Bob as a writing assignment. Some kids took on the assignment and got her done. Some told a little bit about themselves.

Other kids were budding editors. I remember the letter that said, "You wrote all ready in one story Did you mean already? Also, you wrote receipt. Did you mean recipe?" Some kids just used their eyes. "How come when you wrote about the robbers and the skunk, you said in the story that there were four robbers, but in the picture of them in the motel bed, there were five of them?" (Answer: My father went into the

army for World War II right after he finished writing and illustrating *Homer Price*. Six months later, Viking decided another picture was needed in the robber story, and Bob drew one at his army base in Alabama and sent it to them. Unfortunately, he had forgotten how many robbers were in the story. I guess May had, too, or figured there was a war on, and let the mistake go through.)

Grown-ups sent mail, too. One man said that when he was reading *Make Way for Ducklings* to his kids, he noticed that one of the men on the swan boat looked exactly like Richard Nixon. Another man pointed out that I was pulling in the wrong side of the jib in the sailboat on the cover of *Time of Wonder*.

But for grown-ups, the biggest source of interest was that *Make Way for Ducklings* was a story based on real-world ducks. For fifty years, they sent photographs and news stories of mother ducks, followed by their ducklings, walking across streets in small towns and cities all over the world. A couple of times,

He planted himself in the center of the road, raised one hand to stop the traffic, and then beckoned with the other, the way policemen do, for Mrs. Mallard to cross over.

friends have sent me emails circulating on the Internet of mother ducks leading their ducklings down the street.

The summer I was a junior counselor at the French Camp, an enterprising man in Bucks Harbor started a tour boat business, and he included our island on his itinerary. The boat came by several times a week and slowed off our front beach, while the captain announced through his bullhorn that this was the island home of the famous Robert McCloskey. After a couple of weeks, my father bought an air pistol, a sort of miniature BB gun, and about the time the boat was due to arrive, started shooting target practice on beer cans he threw out in the water. The tour boat stopped coming around.

Several weeks later, I heard my friend Dodie say that he and Dave had been sitting on the porch of the yacht club after work, watching the boats in the harbor, when a girl about sixteen came by, and asked if

they knew where Robert McCloskey lived. Dave looked at her and pointed straight out the harbor and down the bay. That way.

"Uh, how can I get there?"

"You have a boat?"

"No."

"Can you borrow a boat?"

"No."

"You can't get there from here. He lives on an island...You sure you want to see Robert McCloskey?"

"Yeah, it's a class assignment. I'm interviewing him for the paper."

"I hear he don't like people." (Dave was valedictorian of his class.)

"He don't?...Doesn't?"

"Nope. He sits out there on that island with a shotgun, just waiting for people to come and see him."

I told this story to my father, and he laughed. He said someone more helpful than Dave had directed the girl to the Cliffords. Ferd's son Earl had given her a ride out to the island, and she had gotten her interview.

My cousin Kathy says that her mother told her that when she was visiting on the island one time, someone landed on the dock and walked up the path to the boathouse, where Bob and Aunt Dorothy were outside admiring the day. The person asked if Robert McCloskey lived there. Aunt Dorothy said that Bob just turned around and headed into the studio, and she was left with an uncomfortable twenty minutes explaining the situation. Or not.

My friend Sarah says that when she and her husband, Tony, were living in Boulder, Colorado, in the 1970s, a library group had a convention there and asked my father to be their keynote speaker. Sarah said

she went to hear the speech. The auditorium was packed and Bob charmed them, bringing down the house. She said that afterward he was supposed to go to a banquet with the city mayor, but he begged off, saying he had an engagement with Sarah and Tony. The way Sarah talked, he charmed her and Tony as well.

In the late 1980s, my mother persuaded my father to allow the sculptress Nancy Schön to make bronze statues of Mrs. Mallard and her ducklings and put them in the Boston Public Garden. My father was increasingly private and did not want to become engaged in another project. Mom nudged him, and he got to know and admire Nancy and her work. Nancy made the Ducks. It scarcely seemed possible then that anyone could have added to the renown of *Make Way for Ducklings*, but Nancy did.

As I've mentioned, Nancy also contributed to the peace process between the United States and the Soviet Union. When Mrs. Gorbachev visited the United States, she and Mrs. Barbara Bush discovered that they shared an interest in teaching reading to children. They went to see the Ducks in the Boston Public Garden. Mrs. Bush decided that, as part of the peacemaking effort between the two nations, the children of the United States should give replicas of the Ducks to the children of the Soviet Union. The Duck replicas were cast and shipped to Moscow. When the peace ceremonies were celebrated and the START treaty signed, Nancy and Bob went with the Bushes to the Soviet Union to take part in the Duck installation.

In 2003, we heard that children in Massachusetts had started a campaign to make my father, as author of *Make Way for Ducklings*, the official Massachusetts children's author. Maureen Foley, a children's librarian in Chelmsford, Massachusetts, had discovered that the state didn't have an official children's book author. She organized the children to send three hundred paper ducks to the State House.

Kids at another grade school in Springfield, Massachusetts, heard about the McCloskey

campaign, and they started a counter-campaign to make Dr. Seuss the official Massachusetts children's author. Springfield was the hometown of Dr. Seuss. The Massachusetts legislature listened to both sides and reached a compromise. They passed a bill in which Dr. Seuss became the official children's author, since he came from Massachusetts, and *Make Way for Ducklings*, about ducks in Boston, became the official Massachusetts children's book.

People have asked me what my father thought of this honor, to have his *Make Way for Ducklings* named the official children's book of Massachusetts. I guess (he never said much, but I got good at reading between the lines) that he was pleased and thankful, but not over the moon.

My father had won so many awards by then, that he knew that external awards were fine, but secondary to the artistic process. The true reward lay in actually doing the work. His puppets and paintings, which never won any awards, were worth as much to him as the books which won the praise of the world.

Still, he was down to earth in that he knew where the money came from and did not disdain his readers, ever. He was grateful that people had found his books worth supporting with their hard earned money and with public recognition. Our family lived on the support of people who loved his work.

And my father always had a child alive in him, and was happy that children found pleasure in his books.

Maybe I read this interpretation into him, but this is how I believe he thought about his work and the honors he received for it.

I have almost never boasted about my father's fame. In Maine at least, almost everyone has heard of him, and whenever I meet someone new, they almost always ask, "By any chance, are you related to...?" "Yes," I say, "he was my father."

But I think three times in my life I have boasted about my father, and all three times, the people looked at me blankly. "Who?" Served me right.

Dinner with My Parents

When I went to dinner at my parents', Bob used to pick me up at the dock on the mainland. Punctuality is a virtue in our family, and it was a pleasure to park my car in the McCloskey space at the cove a couple of minutes before 5:30. I went down to the dock, stepping carefully if the high tide had covered the low place in the path, onto the pier, and down the runway to the float, where I stood contemplating the cove. There was Phil and Flo's handsome Dutch sailboat named *Amity*, with her little dinghy, *Calamity*, hanging off her stern: a lifeboat in case of trouble. I was reminded of the handsome black boat friends of my parents used to own: the *Rogue*. Its black tender, all of eight feet long, stubby and foolish looking, was the *Me Too*. There were Dick and Bobby's lobster boats on their moorings, and Edee's kayak across the cove. I remembered the bright red twelve-foot-long speedboat her father had bought for his second wife: the *Ruby Yacht*. A jug of wine, a loaf of bread, thou, and a fast boat.

And now I could hear Bob's boat humming across the water, coming into view around the point, at a good clip. He suddenly slowed to prevent the wash from his boat from rocking the boats in the cove. There he was, coming up to the dock at the perfect angle, reversing, revving her, twirling the wheel, and coming to a calm stop at the dock.

"Hello, Juanita!"

"Hello, hello!"

As I stepped into the cockpit, Bob gave us a push away from the dock, and we were off, going home to the island.

The engine noise prevented conversation, so I admired the (usually) calm evening, and the glow of the yellow evening sun on the water. When we reached the island, Bob sometimes said he had to pick up something at the boathouse, and we went into his studio. Most times, Twenty Twenty was stripped down so Bob could work on his innards.

Sometimes, there were new swatches of cloth, or new latex casts of his head or hands or feet. Sometimes he was put together with his black dark glasses, which made him look sinister. Other times, his little bead eyes looked vulnerable.

Sometimes there would be a new painting. I liked Bob's paintings, calm and precise. I admired one painting of a rowboat with rocks and gull and shadow of a woman. He gave that to me.

Another time, I admired a painting of a ruined church in Taxco. I am sorry that I lost it in a life crisis.

We went up the path to the house. Several years before, Bob had remarked that the island had lots of birches, but no maples. I had replied that I had a young two-foot maple in my yard. I had dug it up and given it to him, and he had planted it. Now he pointed it out, ten feet tall and thriving.

"Look at your maple tree!"

At the house, Mom was waiting.

"Hello, Jane!"

"Hi, Mom!" And we hugged.

She had dinner mostly ready, usually a roast of some kind in the oven, because she knew that I did not do much cooking. Lamb was a favorite, with the smell of meat, garlic, and rosemary filling the kitchen. She had the salad made. Bob opened me a beer, and they had their drinks, and we went into the living room, where we sat on the couches to tell our news.

Mom said that Sybil, the black cat Sal's law school roommate had rescued from drowning in the Charles River, was a good hunter and was protecting the garden from mice. Mom asked me if I would take care of Sybil in the winter when they went to St. Thomas. Sal couldn't take her because at that point, she and her husband, David, had two cats of their own, and a dog who chased Sybil, not to mention a new baby. I said I would.

I told of my friend Terry's Afghan dog who ran over a five-gallon bucket of wood stain and spilled the whole toxic batch into the ground. I worried about poisoning the earth, but not much about the fact that we worked with the stuff.

Bob asked after Richard, Terry's husband. Richard and Terry had come over last year and Richard had sprayed pesticide into a wasp nest on the gable eaves over the porch. Bob had decided he was too old to go crawling around on roofs, and Richard had offered to do it for him. Bob had then asked Richard to clean up some of the blowdowns on the island. Richard was a shy man of few words, as was my father. They had taken a liking to one another.

Bob said that Hamilton, his home town in Ohio, was planning a fifty-year celebration, and they wanted him to be the guest speaker. They wanted to plan the whole weekend around him. In earlier years, he had been ambivalent about Hamilton, but he seemed to be mellowing and pleased with the invitation.

Mom said that the garden was doing pretty well, in spite of the drought. Did I want to take home some green beans?

Bob turned on the television to hear the weather report. Then it was Dan Rather with the news. Mom had dinner timed to the minute, going into the kitchen to cook the green beans during the last commercial break. I followed her, and she had me set the table in the corner of the big living room overlooking the bay to the west. The news finished, depressing as usual. Bob was muttering about the Bottom Line. Mom brought the roast out of the oven and set it on the big Blue Willow platter, with roasted potatoes and carrots. I carried it out to the table. Bob tested the carving knife with his thumb and made sure it was sharp enough. Mom brought out the beans, while I got the butter from the refrigerator. Mom and I sat, while Bob carved.

Look at the sun! Mom loved the sunsets, and never tired of pointing them out. We never tired of hearing her. It was a wonderful sun from our western windows, and through the long season from May through November, we could see it move around the horizon from north to south to north again. "Red in the morning, sailors take warning: red in the night, sailors delight," Mom said. Usually the sky was red.

Bob was serving the lamb and the vegetables. Peggy? You want it rare? Yes please, no, just one slice. No, not that one, it's too big. Bob frowned and gave her a smaller piece. No potato, well just a half. Mom's resentment for the need to diet showed. My father's impatience showed. Janie, two pieces for you? Potato?

I told them about my friend Larry, who kept my car running. He had made a float for the Fourth of July parade, a model of the *Titanic*. It was sitting in his yard all summer, and I regularly saw tourists who had pulled over to take its picture. Last year he welded the front of two cars together so that one went backward as the other went forward. The year before he had made a small biplane, which roared down the parade route, but never got off the ground. Larry loved to fly his real Cessna, and said that our family's island was his island too, because from the air it was shaped like the letter L. Whenever he flew over my place on the mainland, he gave me a buzz.

Bob said he had come up with two new characters, Polly Ethel Bromide and her boyfriend, Urban Sprawl. We laughed. I learned later the Urban really is a man's name and that a number of popes were named Urban. My father was not one to hold forth on politics. When he talked about Polly Ethel, he was talking about pollution and our overuse of chemicals. When he talked about Urban Sprawl, he was talking about overpopulation and human beings overrunning the earth.

Mom had taken up knitting again on their last trip to St. Thomas, and she had knitted a handsome red cardigan for herself. Now she said she wanted to knit a hat and booties for Sal's new baby, Samantha. One of the new issues at that time was flammable baby bedding and clothing, so Mom wanted to make Sama's hat and booties out of flame retardant yarn. Anyway, Mom said she had called a couple of yarn companies to find out if their wool was flame-retardant, but that none of the companies was helpful, so she had decided to go with the wool she liked best. What did I think of green for Samantha's hat and booties? I said sure, it sounded good.

Bob turned to me and said, "She's going to dye 'er extremes!"

Aww!

We complimented Mom on the lamb, which was perfect as usual. The salad was also fine, with a scallion, leftover peas, and a leftover hard-boiled egg added to the lettuce from the garden. After dinner, Mom put away the food while I washed dishes. Mom set aside a couple more slices of lamb for me to take home, and some green beans. Bob lit a fire in the living room to take off the chill. When Mom and I

came into the living room, which was now cozy in the darkening evening, Mom said that she wanted to watch *Masterpiece Theatre*.

Bob said, "Oh, you just want to watch your old boyfriend."

"What?" I said.

"Didn't she tell you? She used to go out with Alistair Cooke!"

Mom looked pleased.

"You did?" I asked.

"Yes. He was a nice man."

"He was a stuffed shirt!"

"You're just jealous. He was very nice."

"Hmm. Well, you have fun. I'm going down to the studio for a bit."

So, Mom and I watched *Masterpiece Theatre*. I didn't learn any more about Alistair Cooke, except that she was dating him when she met Bob. After she met him, Bob was the one for her.

An hour later, Bob came up to the house, and we collected flashlights and food gifts. My mother and I kissed goodnight, and Bob and I went down the dark path to the boat, where the water still held a little light from the day. We went quietly across to the cove at slow speed, and ghosted into the dock. I kissed my father good-bye.

"Good night, Bob."

"Good night, Juanita. Take care."

We both gave the boat a shove away from the dock, and I turned up the path to my car. My father slid his boat among the other boats and out of the cove toward home.

The Paranormal and the Weird

My father was skeptical about the paranormal. When some friends of my parents claimed that their house near Portland was haunted, my father had fun teasing them. Still, he never let his skepticism get in the way of a story. In the 1950s, he had made some notes and sketches about "the Skribiller," a boy who found a magic pencil. Whatever the Skribiller drew with the pencil became real.

At about the same time Crocket Johnson wrote *Harold and the Purple Crayon*, about a little boy who was also able to create objects by drawing them. My father had plenty of his own ideas and wouldn't have been interested in copying someone else's. My father never talked about his Skribiller, and anyway, I'm sure Mr. Johnson wouldn't have copied Bob either. The idea must have been in the air, or Bob and Crocket Johnson exchanged it by ESP.

The main plot of Bob's book seemed to have been that the Skribiller drew a space ark, which would take all the animals to the moon. The book did not get very far, and there were only a few pictures. The black or brown part of the pictures were my father's illustrations. The blue part was the Skribiller's contribution. We never knew about these sketches until after Bob died.

Over the years, I have experienced what seems to me like the paranormal. I have never allowed skepticism to get in the way of experience: instead, I have learned to be skeptical of relentless skepticism. My father's sketches of the Skribiller have an eerie resonance with my paranormal experiences. Maybe what Bob and the Skribiller drew became real.

I was married to a man named George for a few years in the 1970s, and we moved to Maine. We were lucky to find people who were glad to have us house-sit their houses in winter if we paid the utilities. Some people were just kind, while others thought it was better for the house to be heated and that people living there would discourage possible vandals. My kind parents allowed us to stay with them during the summer.

George and I eventually decided we might buy a house, so one fall day, we took a trip Downeast, where property was cheaper, to look at an old house that had belonged to an old bachelor who had died. The house was pretty filthy and run down, so we decided to think about it. We had to drive home through the town of Hancock, where my grandparents had lived so many years before. My grandparents had sold their house when I was about eight, and had since died. I remembered that their house was near a place called Gull Rock, but I didn't know if Gull Rock was a private family name for the rock, or if it was a well-known landmark. We drove around Hancock Point, and asked a couple of people, but they had never heard of Gull Rock. We came home.

While we drove around, I told George about what I remembered of my grandparents' place: It had a long driveway, and as you emerged from the woods onto the lawn, there was a huge anchor about four feet tall. A sea captain had built the house, and this anchor may have come from his ship. The house had a living room entirely paneled in wood and varnished.

George was working temporarily for a man who later turned out to be a con man. He was certainly impractical. On this occasion, the boss decided he wanted to hire a woman he had met in Ellsworth, which was thirty miles away, to come cook at a new restaurant in Sedgwick he didn't plan to open until six months later. She wasn't a professional cook, didn't have a car, and lived about fifty miles away, in Hancock. The boss picked up the young woman in Ellsworth and brought her to Sedgwick for a conference with him and George, and then the boss asked George to drive her back home to Hancock. So he did. George said that when they got to Hancock Point, where we had been the week before, she told him to slow down for her driveway. There, a small sign read, "Gull Rock."

He said, "Uh, is this driveway about a mile long?"

She said, "Well, it is pretty long."

He said, "Is there a huge anchor on the front lawn?"

"Yeah."

He asked, "Does the living room have varnished walls and ceiling?"

"Yeah."

It was my grandparent's old house, where the woman and two guys, artists, were, like us, house-sitting for the winter.

George dropped her off, and she invited us to come back in the daytime to see the place.

The next weekend we went, and there was the long driveway. There was the huge anchor on the lawn, which I had climbed on as a child. When we came inside, there was the varnished living room. George and the young woman and one of the artists disappeared somewhere, and I was left with the other artist. He was painting the lettering on a sign for Clark's Florist in Ellsworth, using a watercolor brush to paint in oil. He was doing a good job staying within the lines, but it took him forever to paint one letter. After fifteen minutes, he gave up in disgust. He said, "I need an oil brush." He disappeared, and I was left alone.

I tried to make use of this time to think about my grandparents, but I did not feel their presence. The furniture in the room was entirely changed. There weren't any books, as there had been when they lived there, so I couldn't read. It was cold and snowy outside, so I didn't want to go out.

After about fifteen minutes, I heard a knock on the front door. I opened it to see a man in his fifties on the step, with an oil brush in his hand. He asked, "Is Steve here?" I said that everyone had disappeared, but might be back any minute, and asked him if he wanted to come in and wait. The man stepped in and explained that he was an artist, and he wanted to lend Steve an oil brush to paint a sign. I said I had noticed that he was having trouble with his watercolor brush.

The man looked around the room. "You know, this is the first time I've been in this house for twenty-five years. The last time I came, there was a fellow living here named Robert McCloskey!" Years later, I was living in the cabin I had built on land I had bought on Deer Isle. One night, when it was overcast with no stars in the sky, I went into my house. When I stepped on the front step of the entry to the

house, a searchlight shone on me straight down from out of the sky. I didn't have time to be startled before it moved swiftly across the clearing and disappeared into the woods. When a shaft of light moves like that, you can figure its point of origin by watching its change of angle. The edge of my clearing was about 75 feet away from where I stood on the doorstep. The angle of the light when it shone on me was pretty much 90 degrees: straight down. The angle of the light when it disappeared into the woods was about 50 to 55 degrees. So, the source of the light (I could see nothing up there) was around 100 feet over my head. There was no sound.

I had lived in the cabin for twelve years and had never seen anything like this searchlight, but I spent the next ten minutes playing with the two lights in my cabin and swinging the door and the refrigerator open and shut trying to duplicate the searchlight effect. I couldn't.

A couple of days later, I invited my friend Richard over for dinner. We had supper and then lay out on the lawn, looking up at the lovely evening. There was not a cloud in the sky. I told him about my maybe UFO experience. As I spoke, a golden cloud drifted over the clearing, a perfect oval, gliding along at a stately pace. As it moved, it went from a fat oval to a long, narrow oval, remaining perfectly symmetrical. Suddenly, I realized how odd this was. Clouds are hardly ever symmetrical, and if they are, they don't hold their symmetry as they change shape. This one did.

I also realized that there was not a breath of air. The trees were still, yet the lone cloud sailed along as if in a good breeze, about 100 feet up. It was golden-white, though the sun had set. Maybe the sun was still shining on the cloud while it was getting dark down below.

I asked my friend. "Richard, do you think that is a UFO?" He had been watching it too, and he said, "Yes, I think it is." We watched as the perfect golden saucer-shaped cloud sailed out of sight over the trees. It was a flying object, or at least a floating object, and it was unidentified.

A month later, I was telling my UFO stories to a woman in Blue Hill. "Oh," she said, "Didn't you hear about the UFO over Largay's parking lot?" Largay's was the local grocery store. She said that it happened in mid-afternoon, and a lot of people were in the parking lot to see it. From her memory and mine, it seemed that the Largay UFO and my UFOs appeared within days of each other, about a month previously.

Some years later, I got to know a young boy named Aaron. He was very athletic, and turned cartwheels and ran and jumped. One day when he came to visit, I was writing affirmations, trying to improve my life.

I am well.

I am well.

I am well.

I am well.

I am happy.

I am happy.

I am happy.

I am happy.

I am filled with love.

I am filled with love.

I am filled with love.

I am filled with love.

There were other affirmations, but these were my favorites. Aaron asked what I was doing, and I told him. I said that if you wrote your hopes down, they would become true. He said, "Really?" I said, "I think so."

He thought a minute and asked, "If I wrote that I can jump over those trees outside, would that come true?"

I said "Maybe, but I don't think so. But I bet you would be able to jump higher than you can now."

That kid was determined. Over the next several days, he filled pages and pages of his notebook with his affirmation:

> I can jump over the tallest trees.
> I can jump over the tallest trees.
> I can jump over the tallest trees.
> I can jump over the tallest trees.

He went away for a number of years, and then came back to visit. We got to talking, and he said, "Remember when I wrote that I can jump over the tallest trees?"

"Yeah?"

He said, "It didn't work."

I said, "I am sorry."

We continued talking. He knew I thought I had seen a couple of UFOs, and that I was interested in them. He allowed as how one night when he was in his old room, a strange light shined in the window.

He looked out, and there was a UFO ship in the sky above the trees around the house. He said that suddenly he felt himself propelled out of the window and up toward the ship. He remembered nothing more. He said he couldn't decide if he wanted the UFO to come back again, or if he was too scared and wanted it to stay away.

The next time he came to visit, I said, "Remember telling me about getting taken up into that UFO?"

"Yeah?"

I said, "Remember your affirmation: 'I can jump over the tallest trees'?"

"Yeah?"

"When you flew out of your window up to that UFO, you jumped over the tallest trees."

My friend Ilona had some psychic power. One time I visited her with another woman, a lesbian named Leslie. Ilona mentioned some premonitions she had had in the past that came true. Leslie asked her if she could read palms, and Ilona said she could try. She didn't actually read Leslie's palm. We sat quietly in a circle holding hands for several minutes with our eyes closed. "You are going to be hit by a tree," Ilona said. We were somewhat disturbed by this remark, but we laughed it off.

Shortly after, a strange woman blew into town. Leslie fell hard in love with her, but the woman left town as suddenly as she came. This was the 1970s, and the woman had the New Age name of Tamarack, which is another name for the larch tree. Leslie had been hit by a tree.

Some years later, Ilona called me late one night around 11:00. I was about to go to bed. It was a dark winter night with silent, heavy snow falling.

"There is a spirit bothering me," she said.

"Oh! What's it doing?"

"Nothing. It's just here."

"Is it a bad spirit?"

"I don't think so."

"Is it a he or a she?"

"A she, I think. I want her to go away."

"Talk to her. Ask her what she wants."

"I'll call you back." She called back a little later.

"She's still here".

"Did you find out what she wants?"

"No, I couldn't."

"Tell her you can't help her and she's bothering you. Tell her to go to God."

She said she would call me back.

Just then there was a clicking on the windowpane. I went over to see a small bird in the snow on the windowsill. It pecked at the glass again, and I opened the window. The bird hopped over the sill and flew across the room to the room divider, where it settled and looked down at me.

The phone rang.

Ilona said, "The spirit's gone."

"I think it's here,"

We talked a little, but it was late, and we said goodnight. I turned out the light and went immediately to sleep. I woke in the morning to see the bird looking at me from its perch.

"Hello, Bird!" I got up and opened the front door. "Do you want to stay? Or go?" The bird flew down from its perch, out the door, and into the snowy day.

The Skribiller didn't tell all he knew. I guess my father didn't either. And neither do I.

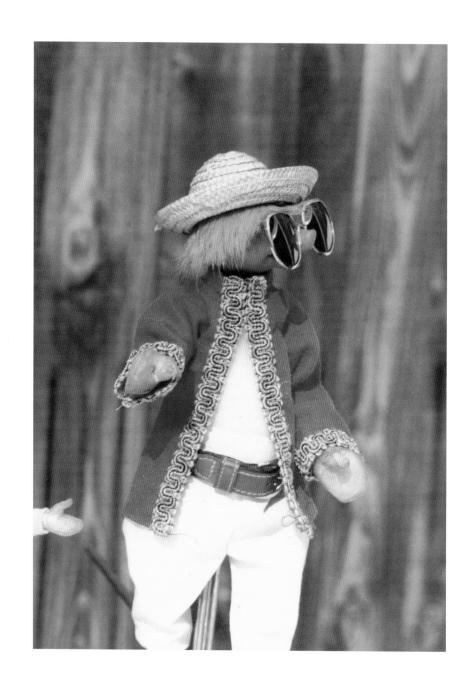

Spies and the Underworld

As Bob got older, he began to look like Twenty Twenty. When he had a cataracts operation in his eighties, he kept the big dark glasses the doctor gave him and wore them whenever he went out. His hair had turned light grey, and when he was due for a haircut, his bushy mop looked like Twenty Twenty's.

Twenty Twenty seemed intertwined with Bob's ongoing interest in secret agents, the Mafia underworld, and spying. I often thought of his talk with me on the Ferris wheel in Mexico: "Some people here are not what they seem. Some of them work for the CIA."

A Mole is an underground spy planted in the enemy's stronghold. Mr. Pinkerton, Bob's pigeon, was either a private eye or secret agent. The mouse, like the Dormouse *in Alice and Wonderland*, was maybe a sleeper.

I thought that Bob's interest in spies was weird, but when I think about it now, there were a number of real spies in our lives. My friend Sarah's father worked for the CIA as head of the New England bureau. He seemed like a good civil servant and citizen. He was the commodore of our yacht club, secretary of his college class, and active in the Maine Republican Party. When he retired, he grew orchids in his greenhouse. He was kind and loved his wife and family. Still, he must have done some secret work.

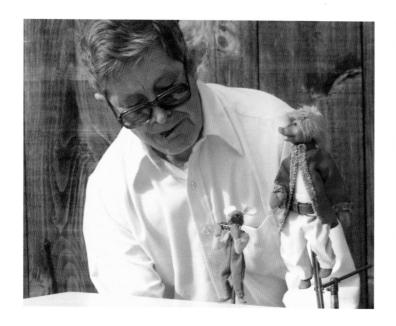 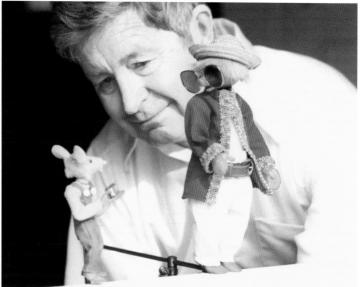

One summer night when we were teenagers, Sarah and I met some boys at the yacht club. One of them asked her name, and she said, "Sarah Jayne."

He asked, "Sarah Jane what?"

She laughed and said, "That's it—Sarah Jayne."

He said to the other boy, "She doesn't want to tell us her last name. I bet her father works for the CIA."

Just recently, when I told Sarah I was putting her father in my book, she said, "Well actually, there are two, no, three other guys in the area who were in intelligence." She named names, and I know them.

Anyway, maybe Sarah's father recruited my father to work for the CIA when we went to Mexico. It seems improbable, since I don't think my father would have wanted to work for the CIA. He was a loner and did not like his time in the Army. He felt it was best not to get entangled in government.

Or maybe Sarah's father tried to recruit my father, and even though my father turned down the job, the solicitation awakened his awareness of spies in our midst. Or, maybe Sarah's father (or someone else)

preyed on my father's love for Mom and Sal and me and made him feel he had to do his bit to protect our country from the U.S.S.R. Or nothing happened at all.

Another boy I knew had a father who was a career officer in the army during the Vietnam War. His father was rumored to be doing secret work. One calm winter night, his father rowed out to check his boat on the mooring and drowned. Maybe that's what happened, but a lot of people wondered. He was in the prime of life.

During World War II, coastal towns organized a warden system to keep watch for submarines and possible spies. My parent's friend John had been a warden in Brooksville. He said that once he saw footprints coming up from the beach through the snow to the road, where they disappeared. John said there was a well-known case in which two men came ashore on Hancock Point, where my grandparents lived. A woman who saw the strangers there reported them to the police.

Just a few years ago, the *Bangor Daily News* ran an article on the old story about the spies in Hancock, confirming what John had said. Mary Forni of Hancock reported them to the police, and the spies, Germans, were later picked up in New York City. They were supposed to be hanged, but after President

Roosevelt died, their sentence was commuted by President Truman.

People worried about spies in Stonington during the War, too. My friend Nancy took me to see a summerhouse she had painted. The house, which overlooked Stonington Harbor and the waters to the south, had a telescope mounted on the veranda. For years during World War II, Stonington people had manned that telescope round the clock, watching for U-boats down the bay. Oh! And my friend David was stationed on the Navy spy ship *Liberty* in 1967. He listened to and translated radio messages. The ship was wandering around the Mediterranean, eavesdropping on radio chatter in various languages, when the 1967 Arab-Israeli War broke out. The *Liberty* cruised toward the eastern end of the Mediterranean, where it was torpedoed by Israeli naval forces.

The torpedo hit the *Liberty* where David and the other translators were working. Water poured into the ship. David was blinded by shrapnel, and climbed by feel up the ladder and out of the bombed compartment. The officer in charge descended repeatedly to try to rescue others in the compartment. Then he ordered the hatch locked down to keep the water in the ruptured compartment from inundating the ship. David was blind for about two weeks until they could operate on his eyes. thirty-four men on the *Liberty* were killed and 174 wounded.

The Israelis claimed that they did not know the *Liberty* was an American boat, and the U.S. Government under President Johnson never investigated the incident. In any case, David was a real intelligence officer on a real spy ship.

Once you start looking for spies, you find them everywhere. When I told my father's friend Read at Parker Ridge, the local retirement community in Blue Hill about all the spies my family had known, she said, "Well, as a matter of fact, my husband, Bob Thrun, was in the OSS during the War." He worked for General Bill Donovan, as one of two 'number three men' in the service." The OSS was the Office of Strategic Services and was the prototype of the CIA. Read also said that in the 1960s her husband saw Julia Child on television.

"I know her!" he said. "She worked in our office in Paris during the War!" In 2008, documents confirmed that Julia Child was a spy, too.

Oh, yeah. Bob went with Mrs. Barbara Bush and her husband when President Bush went to Moscow to sign the START treaty with the Soviet Union. Before he was President of the United States, George H.W. Bush was the "number one man" in the CIA: the spy in chief.

But the person who may be most responsible for the emergence of my father's interest in spies and the underworld was his namesake, Robert McCloskey, in the State Department.

When I was about nine, just before the first year we went to Mexico, I remember my parents saying that we were getting mail meant for another Robert McCloskey, who lived in Brewster, New York. We lived in nearby Croton Falls, New York, but our address was RFD1, Brewster, New York.

The other Robert McCloskey was Robert J. McCloskey, but even that didn't differentiate him from my father. My father's true given name was John, which he changed, though never legally, to Robert McCloskey. Some of his official papers continued to call him Robert J. McCloskey, just like the Robert J. McCloskey in Brewster.

My parents said that the other Robert McCloskey was in the State Department in the government. Probably they found out by opening his mail by mistake. At the time, I had no idea what the State Department was, but recently, I have begun wondering if his State Department job was really a cover for work in intelligence, since State Department diplomatic jobs are notorious cover jobs for intelligence agents.

According to the *New York Times* obituary of 1996, the other Robert J. McCloskey's government service was as follows.[1]

Robert J. McCloskey (1922-1996) served "in the Marines during the Second World War ... joined the Foreign Service in 1955, and, after a stint in Hong Kong, returned to Washington He was a career diplomat who served as the State Department's spokesman during the Vietnam War, rose to become an Assistant Secretary of State and later was appointed Ambassador to Cyprus, the Netherlands and Greece"

According to government archives,[2]

General Records of the Department of State (Record Group 59)

Records of Robert J. McCloskey, 1952–76; Intelligence Reports: International Communism, 1950–74; Intelligence Reports: Developments Significant for Propaganda; Intelligence Notes, Research Studies, NIS Committee Minutes, 1965–74; Intelligence Reports on the Soviet Union and Eastern Europe, 1942–60; National Intelligence Surveys on the USSR; Subject Files for the Undersecretary of Political Affairs, 1966–70; Ernest K. Lindley Files, 1961–68 (S/PC); National Security Council Files, 1964–76 (S/PC); Senior Interdepartmental Group Files, 1968–72 (S/PC); Records of the Planning and Coordination Staff, Miscellaneous Files, 1972–74; Records of the Planning and Coordination Staff, Subject, Country, Area Files, 1969–73; records of the Policy Planning Council, Subject, Country, Area Files, 1965–68. Materials open. Contact the Archives II Civilian Records Staff. The other Robert J. McCloskey was indeed involved in intelligence:

I suspect that Bob suspected he had a namesake in intelligence back in the 1950s. So, it should not be surprising that Bob began to think of spies, especially since less than a year later he had a brush with real spies in Taxco. By putting himself in the shoes of the other Robert McCloskey, my father might have begun to tap into the spy aspects of his own personality and of the people around him.

If Bob imagined himself in the shoes of the other Robert McCloskey, I also find myself confounding the two Robert McCloskeys.

Here is a quote on the Internet: "I know that you believe you understand what you think I said, but I'm not sure you realize that what you heard is not what I meant."

I suspect that the other Robert McCloskey said it, but my father might have said it in an existential communication moment.

But if Bob was interested in the other Robert McCloskey, the other Robert McCloskey was also interested in Bob. Just as Bob received letters intended for his namesake, so the other Robert McCloskey received letters intended for Bob. I found these letters in Bob's papers just last week.

DEPARTMENT OF STATE
WASHINGTON

December 19, 1967

Mr. Tim Scully
828 Mountain Road
West Hartford, Connecticut

Dear Tim:

I regret, as I have on previous occasions when
I was mistakenly addressed as Robert McCloskey,
I am not the author of Homer Price, Make Way
For Ducklings, and those other wonderful books.
My job, I have been convinced, is nowhere near
as much fun or satisfaction as my namesake's.
Like you, I hope one day to meet the other
Mr. McCloskey.

I am enclosing a copy of my letter to him, as
well as forwarding your letter to him.

Sincerely,

Robert J. McCloskey
Deputy Assistant Secretary
for Public Affairs

DEPARTMENT OF STATE
WASHINGTON

December 19, 1967

Mr. Robert McCloskey
Scott Islands
Cape Rosier
Harborside, Maine

Dear Mr. McCloskey:

The enclosed letter from Tim Scully, which I
feel is perhaps typical of many you receive,
was sent to me recently.

I have written to Tim to explain that I am not
the real Robert McCloskey, and that the world
I deal with is more often the unreal one than
is that of Homer Price's.

I wish I would receive more mail like you do.

Sincerely yours,

Robert J. McCloskey
Deputy Assistant Secretary
for Public Affairs

Enclosure

The other Robert McCloskey seemed to be interested in the same questions as my father. What to show and what to hide; when to tell the truth and when to speak obliquely or remain silent; and when to trust and when to keep their own counsel.

As far as I know, the spy master and the puppet master never met.

[1] www.nytimes.com/1996/11/30/world/robert-j-mccloskey-state-dept-spokesman-dies-at-74.html

[2] www.archives.gov/research/accessions/2002-quarter-2.html

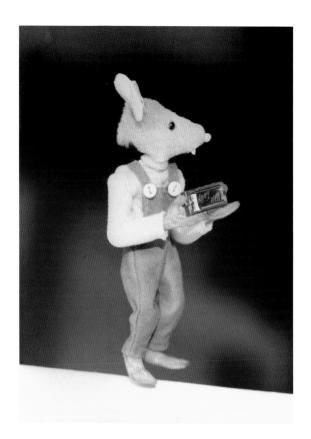

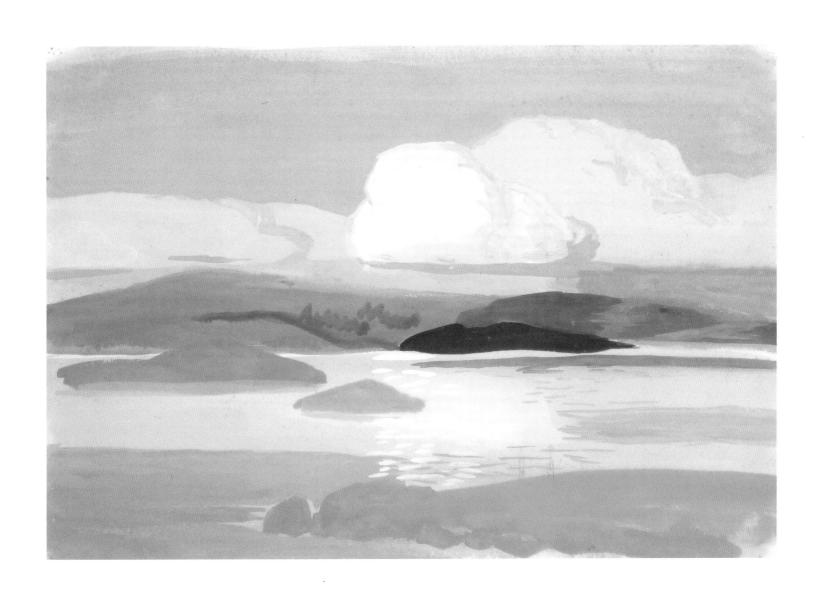

Mom Dying

In the 1980s, Mom and her childhood friend Hilda went on a tour of Scandinavia. During the tour, both of them got sick with a terrible flu, and had to leave the tour and fly back to New York City, where my father met them. He put Hilda in a limousine to her retirement home with medical facilities in Connecticut, and drove Mom home to the island, where she spent most of the summer lying on the couch. Two years later, both Mom and Hilda developed emphysema.

Later, I read a book by a writer who had lived with a family in Sweden. She said that the older man who was her host had emphysema, and that she took slow walks with him in the afternoons. He said that until a few years before, he had been hale and hearty, until he got a terrible flu, and then developed emphysema.

In the last two years of her life, Mom read Bernie Siegal's stories of people who beat cancer. They didn't always live, but if they died, they died with love and beauty. She found a book by an Asian author about learning to breathe with emphysema. The breathing lessons included yogic breathing to increase spiritual well-being as well as to increase lung power. Mom adopted the mantra "Life and Light and Love."

Before she got too sick, Mom and I went on a number of trips to local points of interest, the places you never go to see because they are always there. We went to the Jonathan Fisher House, which belonged to a local minister from the early 1800s who was a theologian, writer, illustrator, furniture maker, and diarist. He claimed that someone had sighted a tiger on the Blue Hill Peninsula. Maybe a ship from Maine in the China trade was bringing it back for a circus and it escaped.

We went to see Mom's childhood home in Camden, which is now the bed and breakfast, called the Victorian by the Sea. We went to Islesboro by ferry, and wandered about the island. We went to concerts.

During their life together, my mother had sometimes felt resentful of my father's extreme focus on his work. In the last years of her life, she let go of her resentment and retained her love. She repeatedly expressed thanks for the gifts in her life. I remembered that she and my father had been married on Thanksgiving.

Mom went into a nursing home, and my father visited her daily from forty miles away and stayed with her for a couple of hours. I was not there for my mother in her final illness as much as I should have been. I felt guilty, but I had just started graduate school, and I was afraid that if I quit school to help her, I would never have the energy to start again. I stopped off to see her for a short while on my way to classes at school. Sal visited on her way home from work. Mom faded away after a couple of weeks in the nursing home.

The day after my mother died, my father went off the road and into a ditch. Mary, an off-duty member of the island volunteer ambulance corps, saw him and stopped and stayed with him while she called the ambulance. He was taken to the hospital, where he was declared okay.

I felt sad and guilty. Then a few days later, I was driving to Blue Hill, thinking of her being cremated, maybe at that moment. And in that moment, my guilt was swept away. I felt her beaming love to me. I had always loved my mother, and I knew she loved me, but this was a purified love beyond what we had known when she was alive. For the next year, whenever I thought of my mother, I felt her love for me in my chest. Years later, after my father died, I took an inventory of Bob's pictures, with photographs. This is the way the picture of my mother came out.

After my mother's death, my father moved from my parents' home on Deer Isle to a condominium at Parker Ridge, the local retirement community in Blue Hill. There, he met a woman named Read. She had been an architect, and had traveled extensively in Italy looking at art there, so they shared a love of Italy and its paintings and architecture. They also shared a love of Maine. Read had a summer home in nearby Sullivan and Bob had the island, so they took turns visiting each other's place, though Bob was less willing to spend equal time away from the island. They went to California for several winters, and to Italy for another.

In 2000, the Library of Congress designated my father a Living Legend. My father was then too frail to travel to Washington, D.C., for the ceremonies, so Sybille Jagusch, chief of the Children's Literature Center, who had friends in Penobscot Bay, kindly came to Deer Isle to confer the award on him here. Sybille told us that another recipient of this honor was Sesame Street's Big Bird.

Bob Dying

My father had been diagnosed with Parkinson's disease shortly before he moved to Parker Ridge. Studies have now shown that people exposed to pesticides are more apt to develop Parkinson's (remember his joke about Polly Ethel). I remember my father in the 1950s dragging his yellow wax herbicide bar around our lawn to kill the weeds.

Parkinson's did not seem to disable him too much, except that he had to give up his delicate work on Twenty Twenty. In any case, he had admitted a few years before that he thought computer animation had made Twenty Twenty obsolete.

When my father's Parkinson's disease became worse, he went into assisted living at Parker Ridge. Nadine and Sarah and the other kind nurses there took care of him.

As my father lost his independence, it was the first time that Sal and I could do something for him that he couldn't do better himself. His new vulnerability made him more open with his affection. When we parted, my father had always said, "Take care." Now he also began to say, "I love you."

He did pretty well until about a month before he died. One day, when I came to take him out to lunch, he could no longer walk by himself. We had to wheel him out to the car, and the nurse had to help transfer him to the car seat. He looked mad at being so helpless. We went to a drive-in place so that we could eat in the car. When we came back to Parker Ridge, I turned off the engine. Bob was humming a blues tune under his breath and looking mad.

"What song is that?" I asked. He sang a song I had never heard. The jist of it was, "If I was an eagle, I'd fly away and you would miss me."

I said, "I don't know that."

I thought a minute, "I only know this one:

If I had wings like Noah's dove
I'd fly away to the one I love.
Fare thee well my honey
Fare thee well.

"Like that?" I asked.

"Yeah, like that," he said. He looked relieved. He was getting ready to leave us.

You are supposed to say the things you want to say to people who are dying. Soon after the Eagle – Noah's Dove songs, I said to him, "Thank you for being my father." My father, who had done such amazing work, usually looked more embarrassed than proud at ceremonies in his honor. But when his daughter thanked him, he looked happy and proud.

He died a week later.

We had a private service. Sal read *Time of Wonder*, which ends, "A little bit sad about the place you are leaving, a little bit glad about the place you are going. It is a time of quiet wonder—wondering, for instance: Where do hummingbirds go in a hurricane?"

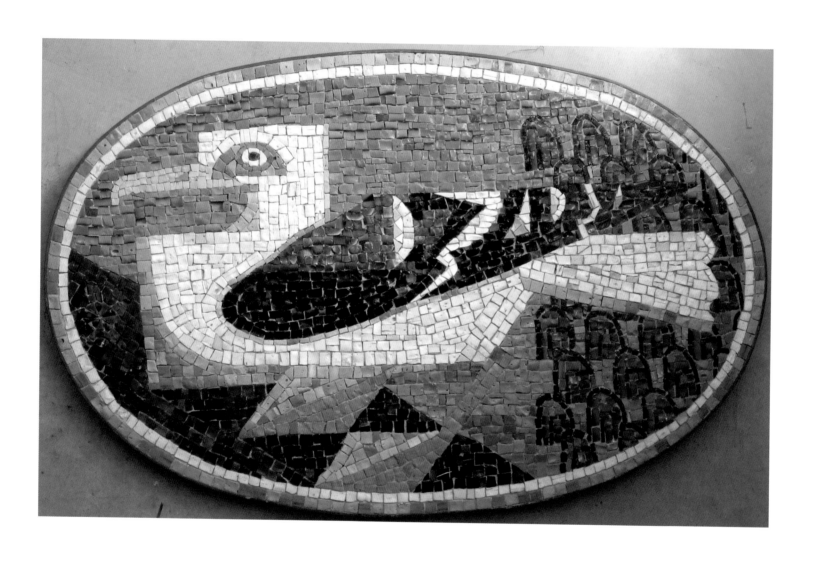

Seagulls

My father drew a lot of seagulls. There was the mosaic seagull he made the year he studied in Rome.

There were the seagulls who acted as weathermen in *Time of Wonder*.

There was the Giggling Gull who accompanied Burt Dow on his trip from home out to sea and into the belly of the whale, the only witness (except the whales) to his extraordinary adventure.

My father painted a number of seagulls, too. These seagulls, like the mosaic seagull, seem to be relaxed and contented with their world.

Later, when he was in his 70s and 80s, he painted a picture of a crowd of seagulls. He spent more time on this painting than any other, working on it off and on for about five years. He finally asked me what I thought of it, and I said that it looked too complicated to me.

I guess he took my comment to heart, because the following was the last painting he made. He spent several years on this painting as well. He set it on the mantel of his condominium at Parker Ridge.

Sal was the executor for Bob's estate. She asked me to go to the island to do the inventory of Bob's paintings. I went to the island with my friend Margie. We worked all morning in the boathouse studio, and found paintings in drawers, closets, and corners. After a couple of hours, we figured we would need to come back to complete the studio inventory, because we found so much. We went up to the house to inventory the paintings there and eat our picnic lunch.

The great chimney where my father had once grilled mussels and shish kabobs was gone. The chimney had been built out of beach sand cement, and after sixty years, began to disintegrate from the salt. It was so huge, it began pulling down the whole house. Sal, with design advice from Bob and an architect, had organized the removal of the chimney and the rebuilding of the house. The Cliffords did the work. I was relieved to see that the result was not a travesty of my childhood home, but a great improvement.

The cold, damp, dark chimney was replaced by double-paned windows that let in the light and the glory view, and kept out the cold in spring and fall.

The Sea Gull Mosaic that used to sit outside on the great mantel of the chimney had been moved inside the house. Margie and I had just taken a picture of it. We sat on the lawn and I began crying. Margie kindly said she would explore the island.

I was enjoying this sweet, sad time of being on the island, when a real seagull landed on the house roof where the chimney had been. He looked at me intently for some minutes. Then, the gull flew down to the new deck that replaced the old terrace. We sat for a long while, and I cried for my father's life and my own, and for the love we shared.

Watercolor by Samantha (McCloskey) Hawkins

afterword

Sal has her own perspective on our family. Her childhood was less happy than mine, while her adulthood has been happier and more successful. She became a lawyer, and later decided that researching deed titles was less stressful and more fun than being a lawyer. She says researching deeds is like doing crosswords, and it makes a good living, too. She has two children, Samantha and Seth.

They are young adults now, and successful in their beginning careers. Samantha is an artist with computer training who works in computer graphic design. Seth is in the Merchant Marine, second mate on an ocean tugboat. He works in silver as a hobby.

With hindsight, I can say that I was called to a life of contemplation. At the time, I thought I was waiting for this contemplation period to end so I could get on with my real life. Meanwhile, I had day jobs of house painting and a seasonal Christmas wreath business.

In 1986, I got poisoned with chemicals and developed chemical sensitivities. In 1999, I was diagnosed with mercury poisoning. My osteopath said my mercury levels were more than twice as high as his next highest patient.

After my mercury fillings were taken out and the mercury was chelated out of my body, my shy, introverted, inner-focused personality changed and I became an outgoing member of the community. I became the administrator of a group fighting salmon pens in Penobscot Bay, and secretary of several community organizations. Now, since I have begun writing this book, I have reverted somewhat to my old introverted self.

Edee went off to California for many years. While she was there, she studied at the Berkeley Psychic Institute, and she also rehabilitated seals, sea lions, dolphins, and small whales at the Marine Mammal Center north of San Francisco. For twenty years, she has led groups to study and interact with dolphins all over the world, from Capri to New Zealand. She is a homeopathic practitioner.

When Edee came back to Maine, we became friends again where we left off. I left many people behind when I was young, in New York, Mexico, Switzerland, and college. It is a gift that I have been able to reconnect with some of them, especially Edee, my oldest friend.

Marc and Bee Simont sent me a global warming Christmas card last year. Santa is holding an umbrella over his head to protect himself from the pouring rain. Marc has just published a book: a collection of his cartoons against the last forty years of American war. He worries that our warring habit will destroy us all. It is called *The Beautiful Planet: Ours to Lose*.

Nancy Schön is still working as a sculptor. Among her other works, she did a statue of Lentil and his dog, which is in Hamilton, Ohio. Just this summer, she completed a statue of the Bear in *Blueberries for Sal*, which is at the Maine Coastal Botanical Gardens in Boothbay.

The Butler County Historical Society in Hamilton has opened a tiny museum in my father's memory. They also have a doughnut machine. They invited Sal and me out to Hamilton last year, and showed us kindness and hospitality. We briefly met George Turnbull who was a friend of my father's in high school. He said that the last time my father came out to Hamilton, they went down to the river and just sat quietly and watched the water go by.

My father never did get his puppets on television. He did take them down to Weston Woods to show to his friend Morton Schindel. Mort found a dollmaker, Noni Cety, to make the clothes and work with Bob on the puppets, and Bob shared some of his story ideas with her and Mort. A photographer took some pictures and videos, but Mort says that Bob did not seem interested in making a movie.

I never heard Bob talk about the Mouse, but Mort says that the Mouse was named Mechanical Albert. Bob had named him after the Mechanical Albert in Penobscot, Maine, who sold Citroens and could fix them and anything else. Mort says that Mechanical Albert, the Mouse, could fix anything, and crawled inside the cylinder of a car to fix it from the inside out. I remember that Marc Simont told a story in

the Horn Book from August 1958 about how Bob fixed Marc's just-bought second hand Pontiac: he pulled an old mouse nest from behind the fly wheel, and the car started right up like a charm. Maybe Marc's Pontiac mouse nest was another part of the inspiration for Bob's Mechanical Albert. Mechanical Albert also played harmonica.

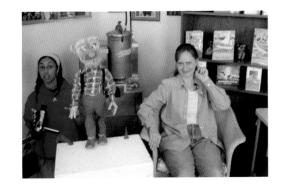

Mort says that Bob was developing two new characters, and had made heads for them, although they had no bodies. For the photo shoots, Bob removed Twenty twenty's head and put the other puppets' heads on his body. Maybe Twenty twenty had finally been perfected, and served his purpose. These new characters were now the focus of Bob's evolving interest. Mort says, "Twenty twenty is no more"

One of the new characters was the Varmit who was a mathematician and spent most of his time laying around in bed, thinking. The other character was a Black Female who was very wise. These puppets are at Weston Woods, and are part of what Mort hopes will become the Weston Woods Museum. Here is the Varmit and friends in front of what looks like a McCloskey memorabilia corner. Note the doughnut machine from Homer Price.

After Bob died, Mort asked Jim Henson, creator of the Muppets, to look at Bob's puppets. Jim Henson said that Bob had been a genius, but his puppets could never have worked. The fish line that ran on the pulleys would crack and break with use and time. The skeleton puppet on the bottom would take two or even three people to work properly, and they could not all fit their fingers on it together.

I believe that my father was more interested in the character of his puppets, and the anatomy of the animals and humans translated into mechanical joints and sinews than he was in actually creating a show. Like Mechanical Albert, my father was working from the inside out. Mort says, "He really loved those puppets."

Over Christmas, Sal, Samantha, Seth, and I got together and sang songs old and new. I sang melody and picked guitar. Sal sang outrageous harmonies, based on our childhood folk songs and blues, her classical piano, and a yodel she picked up in Switzerland. Samantha and Seth sang chorus. Seth took the lead on "Blow the Man Down," while Samantha recorded us on her phone.

Where do we go from here? Maybe we should end with detectives and spies. I have discovered that spies are a common conceit in Muslim Sufi teachings. Idries Shah writes that Sufis are known as "spies of the heart."

Other Sufis also write about spies. "The Odes of Ibnu 'l-Fárid" includes these lines: "My soul secretly imparted its desire for her love to my heart alone, where the intellect was unable to spy upon it … ."

I spent a lifetime detecting and spying on my father, as he did on me. Both of us spied on the world. I guess I have learned that we only know others and the world to the extent that we know our own hearts: love is the motivation, the means, and the goal of spying.

In the end, the best we can do is do our best, and wish each other well. In *One Morning in Maine*, Sal made a wish on a seagull feather she found on the beach.

We can wish on it, too. I send good wishes to all, with special good wishes to Polly Ethel Bromide and Urban Sprawl.

As Bob would say, "Take care."